HIDDEN

HISTORY

of

UTAH

Eileen Hallet Stone

THE
History
PRESS

Published by The History Press
Charleston, SC 29403
www.historypress.net

Copyright © 2013 by Eileen Hallet Stone
All rights reserved

Front cover: Salt Lake City at the turn of the century. *Library of Congress.*
Back cover, top: F. Auerbach's & Bros. department store in the mid-1870s. *Utah State Historical Society*. *Bottom*: Isom Dart, "rider, roper and bronco buster." *Utah State Historical Society.*

First published 2013

Manufactured in the United States

ISBN 978.1.62619.347.5

Library of Congress Cataloging-in-Publication Data

Stone, Eileen Hallet, 1943-
Hidden history of Utah / Eileen Hallet Stone.
pages cm
Includes bibliographical references.
ISBN 978-1-62619-347-5 (paperback)
1. Utah--History--Anecdotes. 2. Utah--History, Local--Anecdotes. 3. Utah--Social
conditions--Anecdotes. 4. Utah--Biography--Anecdotes. I. Title.
F826.6.S76 2013
979.2--dc23
2013040972

Notice: The information in this book is true and complete to the best of our knowledge. It is offered without guarantee on the part of the author or The History Press. The author and The History Press disclaim all liability in connection with the use of this book.

All rights reserved. No part of this book may be reproduced or transmitted in any form whatsoever without prior written permission from the publisher except in the case of brief quotations embodied in critical articles and reviews.

For Daniel

Contents

CONTENTS

Foreword

Nearly ten years ago, the *Salt Lake Tribune* decided to revitalize our existing history column. As its editor, I wanted a diverse team with deep knowledge of Utah's history and the people and events that shape our past and our future.

The first person I called was Eileen Hallet Stone, an accomplished author of *A Homeland in the West: Utah Jews Remember*, co-author of *Missing Stories: An Oral History of Ethnic and Minority Groups* and someone who listens for Utah stories with a third ear and pen in hand.

Hallet Stone proved to be a writer with an all-encompassing fascination with Utah history and the energy, intelligence and will to find stories large and small throughout the state. "Living History," as the column is called, has appeared in the *Tribune*'s Sunday newspaper ever since. And while other writers have come and gone, Hallet Stone has never missed a deadline, tracking down and sharing with readers those little-known stories that have enriched this state.

What you will read in these pages are the essence of Hallet Stone's fascination with Utah's people, its places and its not-so-occasional oddities. Enjoy!

PEG MCENTEE
editor, metro columnist

Acknowledgements

It's not often a person is given free rein to seek out the lesser-known stories about the growth and development of this vast and marvelously complicated state called Utah.

I am grateful to the *Salt Lake Tribune* for giving me such an opportunity, and to Peg McEntee for her consistently insightful edits.

I am indebted to the Utah State Historical Society—to Doug Misner and Greg Walz—who gave much of their time tracking down historical images. And I cannot believe my good luck in having photographer George Janecek recapture and enhance those very historical images that accompany this book.

I thank the University of Utah Marriott Library's Paul Mogren, Walter Jones, Lorraine Crouse and Krissy Giacoletto for their help in charting the rich archival byway of their collections and permitting me to use collection photographs.

I thank, among others, the Daughters of Utah Pioneer museums in Salt Lake City and Parowan, the Murray Museum, the Western Mining and Railroad Museum in Helper, Bill Sanders of the Heritage Museum of Layton, Ogden Union Station and Elaine Carr of the Uintah County Regional History Center, who extended help in numerous ways. I thank Ashleigh Price for her meticulous skill in organizing my early material and being a willing sidekick while touring museums.

I am most thankful to Yayoi Misaka, Marriott Library Preservation Department, for her wealth of knowledge about the Japanese community

in Utah and her willingness to guide me. I thank my husband, Randy Silverman, not only for his support but also for his willingness to go on back roads and stop anywhere at any time to nab a story or two.

I thank Will McKay, commissioning editor for The History Press, project editor Darcy Mahan and senior designer Natasha Walsh for their kind attention to bringing this book to its wide-ranging fruition.

I am beholden to the many people who welcomed me into their homes and offered a treasure, a diversity of stories many of us might otherwise never know.

Finally, I apologize for whatever mistakes or omissions may have occurred.

Introduction

In the 1840s, land west of the Missouri River became a new frontier for courage, adventure, misadventure, freedom and true grit with Utah—the midway connection between the East Coast and the Far West—always in the thick of it.

Some people know Utah for its national parks, high deserts, broad basins, two-mile-high mountains, glacier-formed canyons, the Great Salt Lake and as the ultimate destination for skiers.

Most know Utah's history as a self-created, homogenous state governed by the Church of Jesus Christ of Latter-day Saints, whose members are known as Mormons.

Lesser known are the individual histories of those who challenged and broadened the status quo.

In 2005, over cups of coffee at the Blue Plate, a diner in Sugar House, I was asked by *Salt Lake Tribune* editor Peg McEntee to write a Utah "Living History" column that finds stories long hidden—or lost—in the shadows cast by this vast, 84,899-square-mile territory.

My history beat was to cover ethnic diversity, diversity in the mainstream population and just downright, down-to-earth different stories. Each column had to be 650 words maximum, with no money allocated for travel. Having some experience in the uniqueness of Utah's demographics, I was hooked and ready to take to the road.

As a result, a compilation of fifty-eight stories of diversity, common ground and ingenuity have been selected and gently edited for this book.

Breaking ground in new territory is not without adversity or derring-do.

These stories explore early Utah immigrant pioneers and minority populations—African Americans, Chinese, Greeks, Italians, Japanese, Latinos and Jews—who maintained cultural identities, customs and traditions in a state with practices and theologies quite dissimilar from their own.

Some relate journeys of those who influenced business, manufacturing, transportation, agriculture and mining. Others esteem everyday people. They dip into the lore of cowboys, freedmen, mountaineers, pony express riders and outlaws. They share the experience of homesteaders who "prove up," black families who live in chicken coops, mountains that move and mines that fail.

There were railroad towns, would-be capitals, underground tunnels, spiritualists, suffragists and soiled doves. There was racism in full bloom. Wartime hysteria. Heroic measures. Soldiers and survivors.

These stories come from archived material, current interviews and conversations, filtered by personal recollections, memories, attitudes and more.

With a little digging, Utah is a gold mine for stories.

My dad always told a story in the present tense. It used to drive my mother crazy. She'd often say, "Hal, it happened years ago. Why are you like it's going on today?"

Dad (his name was Hal, although his papers said Harry and his family called him Eddie) would pause and give her that look—you know that look.

"I know that, Florence," he'd say. That was his way of ensuring a presence to the past.

With this in mind, it is my hope that each story included here brings to life the funny and the profound, the ordinary and extraordinary efforts that have helped shape the development of Utah and the settlement of the West.

PART I

New Eyes into the West

Chapter 1

Parowan Was a Welcome Sight for Photography Pioneer

It's difficult to imagine that Solomon Nunes Carvalho, the refined portraitist of southern gentry, the very intellectual who wrote about the "mosaic cosmogony from the original Hebrew tongue," was a rookie in Colonel John C. Fremont's Far West expedition.

Carvalho endured the extremes of an arctic-like winter that more than once had him "chewing the cud of bitter reflection," before stumbling into the safety of Parowan, Utah, frozen to the bone, grateful to be alive.

A descendant of rabbis and cantors who fled the Spanish Inquisition, Carvalho was born in Charleston, South Carolina, in 1815 and earned acclaim both as a portrait painter and as history's first Jewish photographer. Most likely, his innovative techniques that shortened the developing process of daguerreotypes, the early photographic formula utilizing iodine-sensitive silvered plates and mercury vapor, caught the attention of the famous pathfinder Fremont.

Exploring the Rockies for a route to run the country's first transcontinental railroad, Fremont was also running for presidency of the United States. He needed an artist to photograph his military mapmaking exploration and write captivating commentaries to promote his political campaign. With little hesitation, Carvalho traded velvet backdrops for rugged chaps and, on August 22, 1853, joined a band of diverse, dedicated men disposed to following Fremont wherever he led.

Carvalho quickly became his own hostler and a crack shot. He ate deer meat, staved off porcupine (likening the pink flesh to "unkosher" pork) and ran with the

bison. Panoramic vistas quenched his photographic thirst for "scientific and intellectual observations."

Depictions of flora, fauna, Native American dress and geological outcroppings filled his sketchbook. Insatiable, he documented the severity of the expedition's challenges, the loneliness of travel, the absence of comfort and the difficulties maintaining photographic chemical stability in temperatures that plunge well below zero.

From the get-go, the party grappled with prairie fires, raging rivers, stolen horses, dwindling food supplies and delays that led to a winter crossing and mishaps in the Wasatch Mountains. Halfway up a steep pass, a lead mule lost its footing and tumbled several

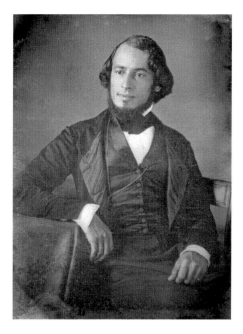

Solomon Nunes Carvalho, half-plate daguerreotype. *Library of Congress.*

hundred feet to the bottom, taking with it the rest of the mule train and supplies. Snowstorms disoriented the men, and slaughtering horses for sustenance doomed them to travel on feet too swollen to fit into boots.

Wearing tattered moccasins, assistant engineer Oliver Fuller died on the trail, his feet "frozen black to his ankles." Lost in deep snowdrifts, Carvalho, too, considered his fate and whether his last bullet would be aimed at a charging animal or himself.

Fremont extracted pledges rejecting cannibalism and vowed to "shoot the first man who hinted at such a proposition." Guided by the stars, he directed his ragtag team safely across the rugged terrain into Parowan.

Emaciated and ailing, Carvalho was taken into the polygamous home of the Heaps family and nursed until he was fit for traveling to Salt Lake City to meet with Governor Brigham Young. He photographed, sketched and marveled at the well-designed cityscape; pondered the providence of polygamy; and resumed his journey westward.

Fremont did not become president. The railroad took another tack. Many of Carvalho's plates were destroyed in a fire. In time, the saga was almost all but forgotten. But history is a gift that, when nudged, keeps on giving.

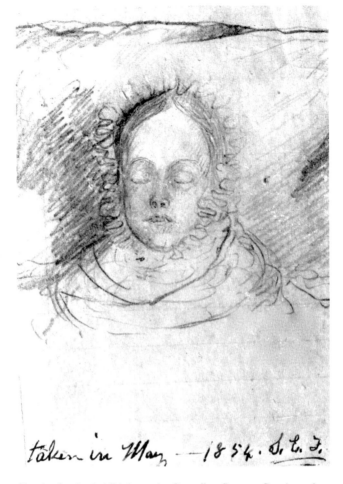

taken in May — 1854. S. L. J.

Sketch of a dead child drawn by Carvalho. *Parowan, Daughters of Utah Pioneers.*

Revisiting Parowan, Carvalho learned of a child's untimely death. Seeing her, he thought the angelic six-year-old embodied more "the gentle repose of healthful sleep than the everlasting slumber of death." He sketched the only likeness for the grieving mother, who said he was "an angel sent from heaven to comfort her."

In this new century, the child's image is projected onto a white screen in front of a packed audience in the basement of Parowan's Old Rock Church. A woman listens intently as I relate the photographer's tale. Nodding, teary-eyed, smiling and seeing her ancestor for the first time, the spirit of Carvalho's historic portrayal comforts her, too.[1]

PART II

Early Towns, Different Stories

Boycott of Gentile Businesses Couldn't Outlast Progress

In downtown Salt Lake City in 1860, it didn't matter that runoff from City Creek brimmed to overflowing the deep ditches that ran along the edges of makeshift sidewalks. It didn't matter that with the rains, Main Street became a bottomless sea of impassable muck and mire. For merchants, who placed wooden planks over furrows so customers wouldn't sink to their ankles in mud, it was business as usual until 1866.

When westward expansion opened up the floodgates of opportunity, it was these entrepreneurs who raced toward territorial Utah, setting up tent stores in rough mining camps, following rail lines and working their way toward the city.

Most were non-Mormons. LDS Church members called them "Gentiles."[2] Among them, Julius and Fannie Brooks built frame houses for lease to pioneers wintering and opened a millinery store and a bakery. Ransohoff & Co. advertised "the highest prices for gold and gold dust." The acquisition of a commercial safe, a rare commodity in the west, nudged the Walker Brothers toward banking.

F. Auerbach's & Bros. carried groceries, boots, dry goods and clothing. The store dealt in gold dust, greenbacks, tithing script and "shin-plaster" currency printed by Salt Lake City. It bought furs and hides, hung out signs for teamsters wanting "Loading" and doled out blankets for use by out-of-town customers who slept, often fully clothed, in store aisles or on counters.

In his memoirs, one Auerbach brother, Samuel, recalls canvas-colored wagons unloading freight in front of the store. "Word traveled fast and

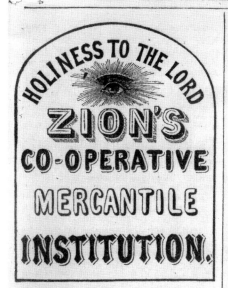

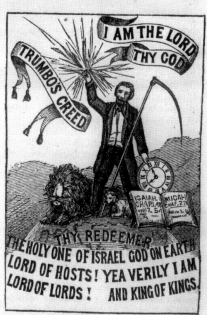

"GENTILE SIGN."

The above cut represents the Mormon "Co-operative Sign"—called by the Gentiles the "Bulls Eye." At the Mormon conference, in the fall of 1868, all good Mormon merchants, manufacturers and dealers who desired the patronage of the Mormon people, were directed to place this sign upon their buildings in a conspicuous place, that it might indicate to the people that they were sound in the faith.

The Mormon people were also directed and *warned* not to purchase goods or in any manner deal with those who refused or did not have the sign,—the object seemed to be only to deal with their own people, to the exclusion of all others.

The result of these measures on the part of the church was to force many who were Gentiles or Apostate Mormons to sacrifice their goods, and leave the Territory for want of patronage. Some few, however, remained. Among whom was J. K. Trumbo, an auction and commission merchant, who procured the painting of what was known as the

This sign was placed in position on the front of his store, on the morning of the 26th of February, 1869, in a similar position to those of the Mormons. All day wondering crowds of people of all classes, little and big, hovered about the premises, and many opinions were expressed as to the propriety of the sign, and whether it would be allowed to remain by the Mormons; but at about 7 o'clock in the evening the problem was solved, by a charge made by several young Mormons, who, with ladders climbed upon the building and secured ropes upon the sign, while the crowd below tore it down, and dragged it through the streets, dashing it to pieces. This should be a warning to all "Gentiles" in future, not to expend their money in signs to be placed on their stores in Utah—*unless they have permission.*

Mormon shoppers were to purchase goods only at stores displaying the all-seeing eye, circa 1869. *Special Collections, Marriott Library University of Utah.*

women and children would hurry down to see the newfangled goods just in from the East."

Business was good, but increasing numbers of Gentiles settling in the territory were viewed as invasive. To protect Mormon autonomy, members adopted a resolution pledging to be self-sustaining. Cited in Orson F. Whitney's *History of Utah*, they also enforced a boycott of non-Mormon businesses believed to be "conspiring against the best interest of the people."

This sentiment affected all downtown non-Mormon business establishments. Within two years, merchants forced into bankruptcy fled the territory. Others relocated north to Ogden or the railroad town of Corinne. Rental property stood vacant. After two non-Mormons, S. Newton Brassfield and Dr. J. King Robinson, were murdered by unknown assailants, merchants walked in pairs at night, carried guns and feared for their lives. Unarmed rancher and butcher Charlie Popper and jeweler Ichel Watters were badly beaten; Ichel was attacked a second time with brass knuckles.

On December 20, 1866, twenty-three incensed businessmen petitioned LDS Church president Brigham Young, condemning the persecution and requesting payment of outstanding accounts owed by church members and a cash settlement on their inventory so they could "freely leave the Territory."

Gentile-owned Auerbach's survived the city trade war. *Utah State Historical Society.*

President Young did not consent, counseling them instead to "wait things out." Whitney writes, "A Gentile exodus was the very thing that he and his people did not desire."

So when Zion's Co-operative Mercantile Institution (ZCMI) and its branches opened in 1869, Auerbach was stunned and infuriated. "These co-ops had the same particular sign over their door, which added to the persecution of the Gentile merchants."

Designed with "Holiness to the Lord" inscribed over an "all seeing eye," Mormon stores were designated for Mormon shoppers.

For the Auerbachs, who enjoyed an amiable friendship with President Young, it was almost the last straw. Samuel records, "We all pinned our great faiths to the mines, believing that with the development of Utah's wonderful ore deposits, the Gentiles would again have a chance in Utah."

The way I see it, you can't keep a good shopper down. Under cover of night, loyal Mormon customers entered Auerbach's by the back door and made their purchases secretly. For a time, the Auerbach name on shipping parcels was carefully obliterated.

By 1870, growth spurred by mining enterprises and the transcontinental railroad precluded all possibility of Mormon seclusion. The LDS Church dropped its sanctions, commerce resumed and, because equality matters, Auerbach's was open for 120 years of business as usual.

Chapter 3

"Un-Godly" Corinne Loved Being a Thorn in Early Utah's Side

In 1868, the predominantly non-Mormon town of Corinne portended a bustling municipality of short-lived infamy. Eight miles from Brigham City on the west bank of the Bear River leading to the north shore of the Great Salt Lake, Mormons called it the "City of the Un-Godly."

Mark Gilmore first settled the town, aspiring to create an all-Gentile borough. With the coming of the transcontinental railroad in 1869, the town became a transfer point, the terminus for trade on the Montana–Idaho trail. Named after the daughter of Union Pacific Railroad Company agent General J.A. Williamson, Corinne was founded in February 1869 by Union Pacific, former Union army officers, entrepreneurs and citizen Gentiles reeling from Brigham Young's 1866 prohibition of trade with non-Mormon merchants and bankers.

Before the railroad ever reached Utah, Brigham Young perceived the increasing numbers of Gentiles in the territory as troubling and looked for ways "to freeze them out." He denounced the proliferation of railroad towns and the countless travelers, laborers, freighters and speculators that descended on them. "Unblushing depravity," gambling hells and debauchery were descriptions bandied about.

Historian Brigham H. Madsen, in *Corinne: The Gentile Capital of Utah*, quotes Young predicting "the destruction of Zion unless some kind of control were exercised over the Gentile storekeepers who were beginning to crowd into Utah."[3]

But the iron horse and the civilization it was advancing could not be stopped. Corinne was wild and independent, grappling with lawlessness

The bustling Wild West town of Corinne. *Special Collections, Marriott Library, University of Utah.*

and disorder. It was ripe with alcohol. "Vinous spirituous liquors" flowed freely from its nineteen saloons. It encouraged romp and assignation with *nymphs du pave*, soiled doves. Its acerbic attitudes toward Mormons added favorably to Washington's fervor to rid the country of polygamy; moreover, it lent impetus to the town's vision of becoming the next state capital. And it was more.

Corinne's epoch was about location and opportunity. Conceived as an active north–south railroad junction, the town's proximity to the Great Salt Lake also guaranteed its setting as a veritable maritime port in the desert. Ore from as far as Bannack, Montana, could be hauled by wagons to Corinne, loaded onto railroad cars and freighted to San Francisco for oversea shipment to smelters in Swansea, Wales. The thoroughly modern, three-hundred-ton, 130-foot, $40,000 steamboat *City of Corinne* was heralded to sail the "briny deep," initiating vigorous commercial water travel.

Union Pacific owned myriad lots as compensation for surveying and platting the one-mile-square site. General Williamson, elected town mayor, auctioned off these parcels and others. Within a week, he sold over $100,000 worth of property. From spare grasslands, Corinne grew into an urban society comprising more than five hundred structures and business enterprises; 1,500 inhabitants; Episcopalian, Methodist and Protestant churches; no synagogue

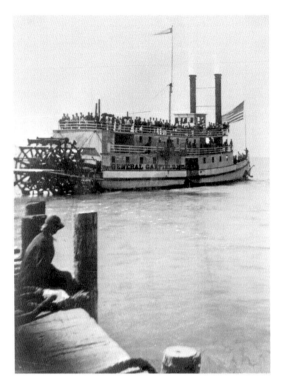

Riding on the *General Garfield* on the Great Salt Lake to Corinne. *Utah State Historical Society.*

but enough Jews to hold a Passover Seder; a free public school housed in the Opera House; a champion baseball team determined to best every "Saint's" team in the territory; ordinances prohibiting the populace from carrying concealed weapons or shooting firearms on the street; and a newspaper, the *Reporter*, that greeted every disembarking passenger of the railroad with souvenir editions listing his or her name.

This paper, published by General Patrick E. Connor, originated in Salt Lake City under the flag *Daily Union Vedette*.[4] In his memoirs, Jewish merchant Samuel Auerbach writes that the *Vedette* was, "of course, anti-Mormon, and passed through many vicissitudes."[5] Some of its articles were sizzling hot, so provocative that its editor, I.M. Weston, received threatening notes to "skedaddle." In 1866, he was beaten and given twenty-four hours to leave town. He did. But the newspaper went from one mining camp to the next until it found a new name, a new editor (Adam Aulbach) and a new life in Corinne.

Utah Northern Railroad took over the northern freight traffic in the 1880s. Corinne's boom went bust. A twenty-five-dollar lottery ticket won the steamship *City of Corinne*. The population dwindled; most departed. Today, only a hint of history remains in wait.

How Murray Got Its Name

There's nothing like an official post office to put a city's name on the map. It's not as if Utah's early Mormon settlement, formerly known as South Cottonwood, didn't have one with the same moniker. It also had its share of postal problems befitting a rough but ready-to-be-honed western town.

In the 1880s, the community along State Street was a "scattered little burg" thriving in commerce, industry, agriculture and neighborhoods. It was also a "place that everyone in the valley at least knew of, but a place not easy to put a name to," wrote Judson Callaway in *The Faces of Murray*.

While correspondence and packages were addressed to the South Cottonwood Post Office, "the corresponding railway destinations were Big Cottonwood, Lovendahls and Franckyln," with a network of mines in between.[6]

In 1883, liquor distributor and South Cottonwood's appointed postmaster Harry Haynes petitioned U.S. president Chester A. Arthur for a new, memorable name. The choices offered were Custer, the recently deceased Indian fighter, or Eli H. Murray, the not-so-liked but well-respected territorial governor.

One of the youngest brigadier generals at age twenty-three, Murray was a supporter of the Liberal Party of Utah. He opposed the practice of polygamy and questioned how one could be a "faithful Mormon and a loyal citizen of the United States." The president chose Murray, and Custer lost another battle.

From the onset, the future city of Murray was destined to succeed with its clean spring water, accessibility to railways and sophisticated smelter operations that began in 1873. Along with imported refractories made of

stellar brick able to withstand extreme temperatures, Murray smelters used clean-burning coke and an extraction process that historian Thomas G. Alexander said "functioned as fluxes, which combined with impurities to free the valuable metals from the ore."

In South Cottonwood, forty saloons whet many a whistle, and tax assessments, licensing and bonding rose accordingly. Postmaster Haynes balked. "We're willing to be taxed," he said, "but not to be robbed."

Digging in his heels, Haynes sold liquor without a license, was cited for civil disobedience and served a brief stint in jail.

Haynes then joined John P. Cahoon and other prominent businessmen to build Murray's commercial district with a general merchandise and liquor distribution, the Salt Lake Pressed Brick Company and a large Commercial Building (also called Murray's Opera House). Add to that the far-reaching Progress Co., which provided electricity to Murray farms, homes and shops and later was bought out by D. Branson Brinton, who sold many of the town's first electric appliances.

In 1897, a confrontation between sheep men and smelter workers turned ugly. A fire was started. A brewery and dancehall were burned. For Martin Willumsen, editor of the *American Eagle*, it was the last straw. For years, he had been advocating "for incorporation through intense editorial campaigning."

Although Cahoon was concerned about unwarranted city regulations, Murray incorporated in 1902 but was unrecognized as a city until 1905. Apparently, the county and city were at odds with the election results.

Chilion Miller, a cattleman and Democrat, became the city's first mayor. Ordinances were prescribed. Pool tables were allowed. Slot machines were not. As for intoxicants, from 1914 until the repeal of the national Prohibition laws, the town was officially dry.

Galvanized by the city's commerce, smelters, mills and granaries, Murray quickly established a school district, volunteer fire station, water works and power plant. Its handsome 1912 public library was partially funded by the Carnegie Foundation. It still stands but in private hands.

The smelter industry increased and diversified the town's population. Latter-day Saint congregations swelled in attendance. Methodist, Baptist and Catholic churches joined the neighborhood.

Rounding the character of this young city, LDS Stake Relief Society president Amanda Bagley set up a "free-baby and pre-school" clinic in 1922 and, with her Relief Society partners, effectively advocated for safe birthing rights.

In 1924, Cottonwood Maternity Hospital was established and many a "Murrayite" born.

Chapter 5

Greek Immigrants Endured Hardship, Clung to Heritage

With destinations pinned to lapels and wearing amulets filled with native soil to be sprinkled over their remains should they die "in exile," thousands of young, single Greek men fled a country unable to sustain them for the promise of work and wealth in early twentieth-century America. To find employment, all they needed to have were "two strong hands."

Most believed their stay would be temporary. They'd work, send money to their impoverished parents, provide dowries for their sisters and eventually return to their homeland in Greece. So they set out for Utah.

Nicholas Kastro, considered the state's first Greek immigrant, had arrived in the 1870s. But it was labor leader Leonidas G. Skliris, the reputed "Czar of the Greeks," who paved the way for these earnest laborers. In 1902, they worked the Lucin Cut-off railroad line across the Great Salt Lake and later broke the Carbon County Coal strike of 1903.

Many went into the mines and smelters of Bingham, Garfield, Magna, Murray, Midvale, Tooele and Carbon County.

Others headed toward Ogden's rail yards, and some ventured into agriculture and sheep farming. The perils were many. Unable to speak English, they were manipulated by labor agents and often swindled by interpreters.

Charged a fee for finding work, these Greek men, almost penniless, bought their own tools and took on the most dangerous jobs at paltry wages. They lived in overcrowded boardinghouses and mining camps, suffered from isolation and loneliness and were forced to pay a dollar a month for medical care that "treated [them] like animals." Bewildered by a population that

Growing up in Greektown, Bingham Canyon. *Utah State Historical Society.*

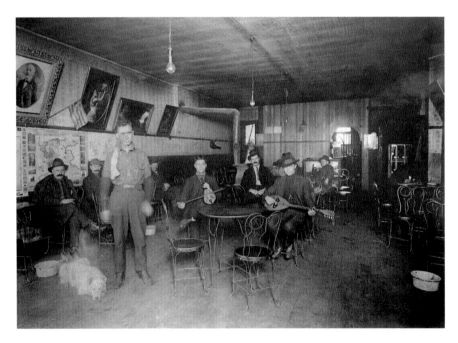

The Open Heart (Anekti Karthia) Coffeehouse in Greek Town, Salt Lake City, in the 1920s. Owner Emmanuel Katsanevas is standing. *Utah State Historical Society.*

detested them as strange and undesirable, they quickly learned that their lives were expendable.

By 1910, Utah's Greek population topped four thousand men and fewer than a dozen women. "Greek Towns" sprouted up in Salt Lake and mining communities offering kinship via cultural restaurants, shops, newspapers and coffeehouses.

Fraternal lodges were formed; churches were built, and Eastern Orthodox priests traversed the state to conduct ceremonial rites of life and death.

When the men chose citizenship over repatriation, they sent for picture brides from Greece. Wearing flowering crowns called *stefana*, couples married in the backyards of company houses and boarding rooms and began raising families influenced by the rich traditions of village life and lore.

Over a cup of coffee, my friend Ellen Vidalakis Furgis explained that Greek folklore, customs and culture were part of Greek American life and part of life in Utah but outside Utah awareness. "These traditions sustained and protected us," she said. "But there were people who didn't understand our practices and ridiculed us, so we kept it in the home, private and apart from them."

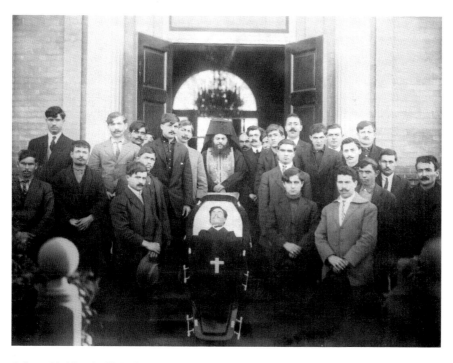

A funeral held at the Holy Trinity Church, 439 West 400 South. *Utah State Historical Society.*

Raised in Copperfield, a mining town above Bingham, Furgis said her mother lived in fear that her father would get hurt in the mines.

"Every day, she'd pack his lunch, leftovers from the night before, and include a piece of bread, maybe a honey-dipped cookie. Then, she'd tuck into the lunch pail a little pouch, a *filahta*, filled with sweet basil, an herb apparently found at the base of the cross. She believed this would keep him safe."

Colds were cured with mixtures of mustard seed and water nestled inside a white dishtowel and placed on the chest. Knotted cloth and prayers took away headaches. Sachets containing softened, steamed onions healed infections. The evil eye, the result of an unintentional comment, was (and is) warded off by wearing an eye pendant or carrying garlic, *skorda*, wrapped, tied with a string and pinned inside a shirt.

Saying "*Sto kalo, sto kalo, kala nea na mou feries*" (a sort of, "go well into the day and bring me good news") at the sight of crows will keep you from harm. Spitting is the best: *ptew* three times, and misfortune is avoided. It worked for the Greeks.

Undeterred by inequity, they thrived, weaving a rich diversity of cultural mores and significant contributions into the very fabric of Utah history.[7]

PART III

Western Entrepreneurs' True Grit

Chapter 6

Walker Brothers' Grit Moved a Mountain into a Silver Fortune

S ome say it's the "biggest little hill in the West."
 Walkerville: six thousand feet above sea level, just over the summit atop Butte, Montana. With more than sixty mines in operation at one time or another, Walkerville is a town rich with historical veins that "winze" deeply beyond state lines toward Utah, Yorkshire and the Walkers.[8]

Matthew Walker Sr. was reared in England's world-renowned woolen industry. Just ten years old in 1824, he was already cutting his teeth on the centuries-old independent clothier trade. He bought and sold worsted fabrics from local craftsmen and became a middleman, undeterred by the encroachment of the Industrial Revolution.

At twenty years old, Walker married Mercy Long and jockeyed for alternative ways to make money with textiles and commercial innkeeping for the clothier trade. He invested heavily in England's Great Northern Railway.

Life was lush, and their new home at Moor End was lively with children: Samuel, Joseph, David, Matthew, Mercy and Emma. By winter of 1847, Walker at thirty-three was considered one of the richest men in Yeadon. By summer's end, the stock crashed. Walker was penniless. America grew ever more appealing.

Walker Sr. converted to Mormonism—an affiliation later renounced by his sons—in hope of finding a new beginning in Utah. He made it to St. Louis with his family, only to die there, thirty-seven years old with barely enough money to pay for his headstone. Cholera claimed the two girls. Heartache crippled their mother.

But his sons headed westward. Challenged by poverty, starvation, risky ventures and irresolvable church issues, they resiliently banded together—with results.

In Utah, the Walkers engaged in freighting, merchandising and banking. Walker Bank & Trust Co., which possessed one of the first safes in the West, represents more than eighty years of a stunning saga. In 1870, the four brothers helped establish Utah's Liberal Party. They secured several mines and were in the right place at the right time, especially for their namesake Walkerville and Alice.

On the advice of their agent, Marcus Daly (a self-taught Irish farm boy with a "nose for ore" who became Montana's "Copper King"), in 1876 the Walkers purchased the Alice Silver Mine from Butte's first-known resident, Rolla Butcher, for $25,000.

They built a twenty-stamp mill using parts salvaged from their idle mill in Ophir, Utah, and new equipment sent from the East. Within six years, the mill paid dividends of $500,000; in seven, Alice produced $4.5 million in silver bullion.

Daly's tutelage and Walker pluck combined to create a mine of innovations. Deliberately sinking a shaft twenty-seven feet below the water line was not only a mining first, but it also dispelled fears of "pinched veins and low-grade ore."

The largest silver producer of its time, Alice had more stamps for crushing ore than any other Montana mine. According to the Butte–Silver Bow Historical Society, Alice was the first mill designed to handle the complex process of extracting silver from base ore.

Walkerville grew from 364 to 4,000 residents in a town of yardless homes; narrow, twisting streets; false storefronts; cottages clinging to hillsides; churches; schools; civic buildings; a theater; a post office; inns; barns; and saloons—everything but a cemetery.

The Walker brothers' visits, while infrequent, focused on the health, safety and well-being of their employees. Single miners boarded at Walker House. Of course, chances were if you didn't live there, you wouldn't be working at Alice. The Walker-backed Broughton store served Alice employees and families.

A fully staffed hospital was built for miners and families; a one-thousand-book library filled a reading room; exercise gear outfitted another room; and, for the light-footed, the award-winning Alice Band played on.

Butte Coalition, a subsidiary of the Anaconda Company, bought Alice in 1910; by 1959, it was over. In 1998, cleanup began. It's a quiet town now. But if you stand on the grassy knoll that is now Alice, you can envision the Walker brothers' conviction that once dominated the raw American West.

Feisty Polish Immigrant Had a Mine of Her Own

S ome say the nineteenth-century foreign-born immigrant to Eureka gave vigorous pursuit to litigious battle, used profanity as easily as one would a linen napkin to daub the corners of a well-fed mouth, was casual with a six-shooter, sank to base levels of insolent greed and eventually dropped dead "of bitterness."

The way I see it, Anna Rich Marks, accused of "using her womanhood too coldly," encapsulates the true grit of western lore.[9]

Born in 1847, during the era of violent pogroms waged against Jews, Anna Rich fled Russian-occupied Poland while barely in her teens, determined to break the bonds of racism, poverty and powerlessness. At fifteen years of age, she married M. Wolff Marks in London, immigrated first to New York and then settled in the West.

While her good-natured husband set up shop in Salt Lake City, Anna, unrestrained by feminine protocol, discovered opportunities unheard of for most women.

During the 1880s through the 1890s, the rough mining camp of Eureka had grown into a well-appointed city extolled for its extensive mineral resources and projected wealth. It was also flush with tales of booms and busts, the rags-to-riches sagas that create heroes and aberrations. It is here, in the Tintic Mining District of Juab and Utah Counties, that Anna stamped her indelible legacy.

Exemplified by local historians as intrepid, ill-tempered, offensive, feisty and "Utah's answer to the [Unsinkable] Molly Brown," Anna was dubbed

Not a weak woman, Anna Rich Marks (left) took to horseback riding and owning mines.
Tintic Mining Museum, Eureka.

the "Volga Vixen," an "illiterate" woman who thrived in the man's world of mining. Had she been a man, perhaps her repute wouldn't have caused a ripple.

En route to Eureka with her husband, a bodyguard and several wagons in tow, Anna was waylaid in Pinyon Canyon by two men who had installed a tollgate and charged a fee for passage. Anna refused to pay. An argument ensued. Her cursing didn't turn the air blue, but the show of guns illuminated her point of view. In the end, the tollgate was torn down, the pistols were packed away and the travelers went on their way. The access route to the mining district became a public-use road.

Once in Eureka, Wolff managed the store, and Anna purchased property. Learning from the tollgate incident, she initiated her own "historic battle," holding up at gunpoint the Denver and Rio Grande Railroad until it agreed to pay her price to cross her land.

In another incident, espying neighbor John Cronin building a fence, she sensed a miscalculation, grabbed a shovel and immediately filled in the postholes with dirt. When he tried reopening them, she jumped in yelling. There's talk that Cronin tried to bury her right then and there.

When Mr. Thomkins tried his hand at fence building, she intervened again. Story has it his life was saved by a plug of chewing tobacco that

took the bullet meant for him. Contesting her possession of a piece of land, another resident, Pat Shea, escaped a volley of bullets by dashing behind a pile of posts.

Some say the Markses slept in separate beds and even lived in separate houses (wishful thinking?). One writer suggests Anna died "consumed by her own burning hatred of life." Yet for a person livid with life, she was certainly vivid in life.

Along with their store, Anna managed Eureka and Salt Lake City real estate, owned the controlling interests in the Anna Rich and White Clouds mines, dabbled in other Tintic mining ground, could saddle a horse, had a say in city issues—she didn't support sidewalks on Main Street, but she sustained miners and their right in "striking for $3 per day, and their freedom to board and trade where they please"—and invested heavily in diamonds.

Buried in Salt Lake City's Congregation B'nai Israel cemetery in 1912, Anna was later joined by her husband. For two people thought to live a world apart, their grave site shows a holding of hands, a tender display of love and, apparently, a life celebrated with few regrets.

Chapter 8

Doctor Creates the Near-Perfect Utah Peach

Among America's peaches, from Paul Fridays Flaming Fury to the Rising Star, few brought more acclaim to Utah than Sumner Gleason's "melting and buttery" *Prunus persica*, the Gleason Early Elberta.

Gleason was born in 1860, in Malden, Massachusetts. His father, a noted horticulturalist, owned a shop in Boston fashioning wooden figureheads for sailing ships. His mother died of cancer when he was sixteen years old.

"The last thing she said to me was 'now be sure and learn to play the flute,' and I did," he said in memoirs gleaned by director/curator Bill Sanders at Layton's Heritage Museum.[10]

When Gleanson's brother went to college, they corresponded in shorthand. When his father remarried, his restless son left home. He worked on his uncle's farm; at his father's store; in a print shop; at a newspaper, where he set type by hand and ran a press; at an insurance company, where he wrote letters with pen and ink; and then as bookkeeper in Winooski, Vermont. He played flute in the Congregational church, never paid more than fifteen cents for a meal and bought a skeleton in the event that he became a physician.

He did, and in 1883, the then twenty-three-year-old Dr. Gleason hung his shingle in Carthage, New Mexico. Treating coal miners and families, he also taught himself dentistry and perfected the art of hypnosis. He even convinced his sweetheart, Edith Crawford, to exchange East Coast sensibility for married life in "barren country [without] a spear of grass or green leaf in any direction."

When the mines started playing out, the family moved first to Denver, then Salt Lake City and south to Spanish Fork, where Gleason's hypnotherapy frightened away perspective patients. Relocating to the north, by 1896, the doctor's family and practice were well ensconced in Kaysville. A Democrat, Gleason ran for mayor in a nonpartisan race in 1906 and won. He bought a new one-cylinder runabout, was appointed school physician for Davis County and returned to gardening, as his family had always done, but used a different approach to farming.

"It took me five days to prove irrigation was not necessary," Gleason reminisced in the August 1943 *Philadelphia Evening Bulletin*. Using a method of "deep cultivation," he successfully raised trees, grapes, berries, apples and peaches in "dry ground."

In 1902–03, Stark Brothers Nurseries of Louisiana, Missouri, initiated hybridizing tests to develop an early bearing variety of the Elberta peach. It shipped four million peach seedlings to growers throughout the country.

Stock No. 162 was sent to Gleason, who planted it "just outside the kitchen door." Through the doctor's cultivating, grafting and budding techniques, No. 162 eventually developed into the "mother tree" of all Early Elberta peaches.

Plump, sweet tasting, beautifully colored and early to bear, the peach faced its last hurdle. Could it travel without bruising?

In 1915, boxes of Gleason peaches were sent from Kaysville on a nineteen-day, 11,500-mile, countrywide, non-preferential parcel post journey of durability. Opened, examined and repacked at each site, the peaches traveled to the horticultural magazine *Rural New Yorker*; went cross-country to the California Agricultural Experiment Station; were rerouted to the Fruit Grower in St. Joseph, Missouri; and then sent back to *Rural New Yorker* before disembarking at Stark Brothers Nurseries.

The review was unanimous. "Not a speck of rot, not a bruise, perfect, and sound as a dollar," Stark Brothers remarked in 1916's *Weekly Reflex*. Advertised in its catalogue as the "quality king of all yellow freestones," it needed only 200,000 genuine Elberta buds to propagate.

For Gleason, it wasn't a problem. His Early Elbertas were thriving in orchards throughout Kaysville, Clearfield, Brigham City, Willard and Santaquin.

Signing an exclusive contract with Stark Brothers to "personally supervise the cutting of buds from original bearing or parent tree[s]," he did that, of course, and put Utah on the peach map—ripening as you read.

Rosenblatts Struck Gold by Turning Scrap Business into Mining Giant

Nathan Rosenblatt was just fourteen years old when he fled Brest-Litovsk, Russia, in 1880 to escape persecution, pogroms and forced conscription into the military, from which few Jewish youth returned.

His father booked him passage on a ship sailing to Ellis Island, and from there, he headed west to Colorado. In 1887, while working in Denver, Nathan met Tillie Scheinbaum, who was sent by their parents to be his wife.

Tillie had crossed the ocean unescorted in steerage. Although the experience left her with a lifelong fear of water, she was young and showed an indomitable spirit. They married in Denver; had two children, Simon and Morris; and several years later moved to Utah, where a third son, Joseph, was born.

Nathan collected scrap metal and rags. He peddled dry goods to miners and learned how to recondition old mining machinery for resale.

The Intermountain region was an innovative frontier for the mining industry in the late 1800s. Immigrant workers flooded the mines, and Salt Lake City was a hub of economic development.

Nathan broadened his business plan. He founded Utah Junk Co. in the family's backyard and built one of the state's first brass foundries to recycle scrap brass. With sons still in their teens, he established American Foundry for Simon to manage and added a custom machine shop for Morris.

Incorporated as the American Foundry and Machine Co., the Rosenblatts processed and recycled junk metals and created a niche in the industry by repairing equipment and machining tools and making metal parts.

Branching into smelting, Nathan leased land to store agricultural machinery and car bodies to be cut to size and used in the smelters.

In 1925, he bought out the Silver Brothers Metals Co. and moved in. The next year, he gave Joseph, who was then twenty-three, an offer he couldn't refuse.

"My father said, 'Look. Here's this little thing I picked up called Eastern Iron and Metal. It's yours. Go ahead and see what you can do with it,'" Joseph Rosenblatt said in interviews archived at the University of Utah's Marriott Library and University of California's Bancroft Library.[11]

With family backing, Joe acquired a storage yard filled with abandoned mining equipment.

"There were pneumatic drills, ore cars and metallurgical equipment for recovering metals such as crushers, ball mills, concentrating tables and sand pumps," he said.

After they were reconditioned and made operable, Joe sold them to small mining companies and, as the Rosenblatts were wont to do, tackled larger projects.

The first involved purchasing the Kennecott-owned Arizona Hercules property adjoining the big Ray Mines in Ray, Arizona.

"It was a substantial investment," Joe said. "My father felt it was a little risky, but worth the gamble. And for me, it was really my first venture away from home. I remember going over mountains roads that had been dug out for single wagons."

Meticulously salvaging the site, Joe not only transported the machinery for repair and resale but also cleaned up concentrates that, when smelted, yielded $14,000.

He then sold the Ray Mine buildings with the caveat to dismantle, move and reconstruct the "huge operation" to house a mill in northern Washington State.

"The task of going into a mill and picking up and moving a fifteen- to twenty-ton ball mill, well, you didn't do it quickly, but you did it safely," he said.

It was a profitable two-year project. When it was finished, the family decided to broaden their business once again by designing and building new equipment. Acquiring patents for a new mucking machine invented by John Finlay and Edwin Royle at Eureka's North Lily gold mine, the company changed its name to EIMCO.

A mechanized, underground mucking machine powered by Ingersoll-Rand motors, this new rocker-shovel could lift a load in its bucket and

deposit it overhead within limited headroom. EIMCO produced and sold hundreds of the machines.

In 1944, the family built a new plant. They developed their own designs, models and air-driven motors that reduced the risk of gaseous air causing explosions in the mines. In creating this equipment, they changed the course of hardrock mining and, as with the rocker-shovel, sold countless shovels domestically and overseas.

They also made advances in the vacuum-filtration products used for separating liquids and solids in the smelting process. They built "custom, exotic" filters. They even entered the uranium-filtration business.

From a yard filled with old equipment to the 1953 recession that stalled economic development, EIMCO steadied Utah's economy by selling locally made products to markets all over the world and just kept on going.

Chapter 10

Newhouse:
From Elite Salt Laker to Pauper

As the dust settles from the razzle-dazzle of another new year (2007), a bejeweled ornament rises in the historic retelling of Samuel Newhouse and his resolution to go west in search of opportunity and adventure.[12]

A flamboyant New Yorker and son of Russian-Jewish immigrants, Newhouse arrived in Colorado in 1882, fell in love with an Irish girl waiting tables at her mother's Leadville boardinghouse, married her, found a financial backer and speculated in mines.

Within a decade, Newhouse owned many profitable mines. He played Pygmalion to his young Ida. He hired a tutor, draped her in "jewels that bespoke nobility" and sent her to England, where she was presented at the Victorian court.

Turning his sights westward toward Bingham Canyon, Newhouse purchased the Highland Boy Property and helped position Utah copper mines and smelting on the global map. He attracted investors such as William Rockefeller and the Guggenheim family. In 1896, he became president of the profitable Utah Consolidated Gold Mines, Ltd.

A quick study, Ida adapted well to the nuances of aristocratic society. Sailing frequently to Europe, she adopted an emissary role for her husband's mining and mineral interests. The couple hobnobbed with British royalty and lived large in London, France, Long Island and Salt Lake City.

In 1907, Newhouse launched a financial district on Salt Lake City's Main Street—the "Wall Street of the West"—and bankrolled the city's first skyscrapers, the Boston and Newhouse Buildings. Located four blocks south

It was a life of opulence for businessman Samuel Newhouse (third from left) at the University Club Roof Garden, Salt Lake City. *Utah State Historical Society.*

of Temple Square, the district was home to the Salt Lake Stock and Mining Exchange. According to Utah historian Philip Notarianni, it also represented "the presence of non-Mormon influence in the city."

Newhouse then went to the western slopes of the San Francisco Mountains near Beaver and bought the Cactus silver mine and mill. He spent more than $2 million to transform the Tent City mining camp into a company town called Newhouse—a regular suburb with cottages and houses, hotels, shops, a hospital and a school. On weekends, the "Cactus Club" offered free dancing.

In 1910, the silver mine gave out, and Newhouse became a ghost town.

One of Utah's wealthiest men, Newhouse acquired other property, including cattle baron Charlie Popper's slaughterhouse. He lavishly entertained in his South Temple (then Brigham Street) mansion, which included a palatial foyer covered in Italian marble opening onto "opulent Persian rugs, deep-piled carpets, and a winding staircase with copper railings."

Soirées were held in salons luxuriously furnished with "velvet upholsteries, red draperies, green silk tapestry, gold-framed paintings, stained-glass windows, and bronze statuary." In the dining room, an enormous mahogany table shimmered with solid gold plates, full silver service and monogrammed crystal.

While women adjourned to a stunning sitting room sheathed in sheer draperies, a concealed electric button released a trapdoor, exposing a bare stairwell. Using a rope ladder, male guests descended into a library stocked with wine bottles, imported liquors and an extensive collection of German steins.

But as it often happens, boom went to bust. At the onset of World War I, Newhouse lost his Midas touch, his securities and his wife.

Their multimillion-dollar home was sold for a song and all its contents auctioned. Until her money ran out, divorcée Ida lived in the Beverly Hills Hotel. In 1937, she lived on the charity of friends and died in poverty.

Samuel Newhouse joined his sister at their chateau in France. He never recouped his losses.

In 1923, the ghost town of Newhouse set the stage for James Cruze's silent film *The Covered Wagon* and another declaration of purpose, one planted by the pioneers who braved tumultuous rivers, blinding snowstorms, starvation and a two-thousand-mile westward trek toward the promise of fortunes found not in the mines but on the land and with a plow.

PART IV

Matters of Inequity

Utah's Latino Community Dates to Mid-Nineteenth Century

In 1850, the number of Spanish-surnamed individuals living in Utah could be counted on one hand. By 1900, there were forty. But it wasn't until the turmoil of the 1910 Mexican Revolution and the enticement to fill America's need for cheap labor during World War I (1914–18) that significant numbers of poor Mexican men migrated to Utah. Their hope was to earn money for their families and return home.

Migrant workers like Guadalupe Rodriguez followed the seasonal path from the growing fields of California to the sugar beets of Utah. Reyes Florez wore out two picks a day hauling twenty-foot-long rails and replacing ties for the Denver and Rio Grande Railroad. Dahlia Cordova's grandfather watered trains in Helper, content to sign documents with an X, but wanted more for his son.

Other immigrants worked the mines of Carbon County; hired on as gandy dancers for the railroads; or became ranch hands, farmers, homesteaders and sheepherders respected for their skill and hard work.

It was these hardworking men who shaped the state's early Mexican *colonias* or communities. In time, they sent for their families and settled in cities along the Wasatch Front, in mining districts and farming localities such as Garland and Monticello, where they spoke their language and held fast to customs.

Fathers embodied the patriarchal, and thus authoritative, mores of Mexican society, while mothers enriched the home with spirituality, authentic foods, *curanderismo* or folk healing and *cuentos*, Mexican folktales.

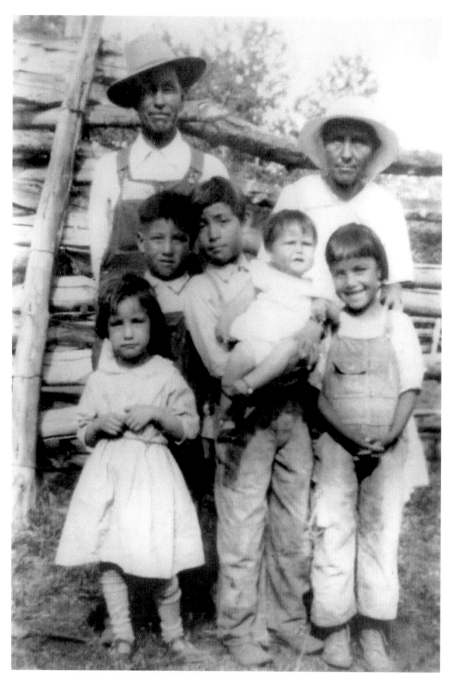

The fine Garcia family in Monticello, Utah. *A gift from Sue Halliday, Utah State Historical Society.*

Churches, such as the Catholic Mission and Our Lady of Guadalupe Parish, opened doors for worship, baptisms, confirmations, coming-of-age *quinceañera* celebrations and weddings. By 1930, the Spanish-speaking population had grown to more than four thousand.

As early as 1848, though, living in the United States was a Catch-22 for thousands of Mexican-born nationals who became strangers in a strange land that was ancestrally theirs.

In 1836, Mexico lost the territory of Texas in battle; twelve years later, it lost the Mexican-American War of 1846–48 and, in signing the Guadalupe Hidalgo peace treaty, surrendered the northern half of Mexico, now California, Arizona, New Mexico, Colorado, Nevada and Utah.

The treaty was written to guarantee Mexicans living in the U.S. territory equal rights and protection under the law, American citizenship, recognition of land titles and preservation of their culture, language and religious rites.

Instead, it was unashamedly sullied.

"Like many others, my father is a descendant of farmers who decided to remain in this country [after 1848] and become citizens rather than go back to Mexico and lose their land," Cordova told me. "Ironically, they lost their land anyway because of the impositions of taxes they couldn't afford to pay."

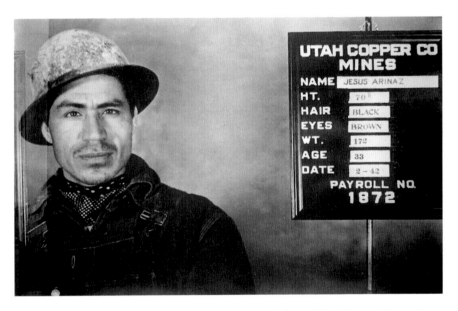

Utah miner Jesus Arinaz. During World War II, a large influx of Spanish-speaking workers found work in the Bingham mines. *Utah State Historical Society.*

From the onset, the Hispano-Chicano community grappled with prejudice and intolerance by those Americans who considered them inferior. They endured inequities ranging from deplorable living conditions and low wages to discrimination in housing and employment.

In schools, Mexican and American-Mexican students were frequently ostracized and prejudged "unteachable" by educators. Caught between two cultures, with no encouragement to learn, many dropped out.

In 1945, the Ogden American G.I. Forum countered high dropout rates with scholarships and back-to-school drives. In 1967, the Spanish-Speaking Organization for Community, Integrity, and Opportunity (SOCIO) strove to unify Utah's Hispanic community, tend to the welfare of migrant workers, address social and economic issues and establish Chicano studies at the University of Utah.

By 1974, the organization had twenty-seven thousand members, and many of their children became Utah's doctors, lawyers, educators, judges, musicians and artists.

Cordova, an elementary school principal, said her father was "one of the first people of color to teach in Utah [who believed] neither ethnicity nor the color of one's skin should hold a person back from accomplishing his or her dreams and aspirations."

More than 200,000 Hispanic/Latino people now live in Utah, yet some of the same challenges hold sway.

"Stereotypes still exist," Cordova agrees. "But we can reject rejection, stand up and correct misconceptions and give voice so others may understand and learn."[13]

Chapter 12

Work of Chinese Rewarded
with Bigotry

On the heels of the gold rush days, 100,000 Chinese men, most from Guangdong Province on the South China Sea, left behind conditions of extreme poverty, over-taxation, ethnic feuding, civil wars and political corruption to seek a better future on America's shores.

They worked in mines and restaurants. They opened grocery stores, rolled cigars, tailored clothing and operated laundries. By the late 1860s, twelve thousand were employed by the Central Pacific to build a railroad from Sacramento, California, to Promontory Summit, Utah.

Many entered the country as indentured servants of Chinese companies. Others arrived indebted to Hong Kong brokerage firms that proffered ticket credit, work connections and inflated repayment programs.

Central Pacific president Leland Stanford praised the Chinese as "quiet, peaceful, industrious, [and] economical." Charles Crocker, the company's superintendent, added that there "was no danger of strikes among them."

Unlike white workers, who were given free board and lodging, the Chinese purchased their own food and supplies and increased Central Pacific's profits by one-third. Comprising nearly 90 percent of the workforce and working twelve-hour shifts, they laid 1,800 miles of roadbed through the country's most rugged terrain.

They were legendary in "shoveling, wheeling, carting, drilling, and blasting rock and earth" with nitroglycerin while being lowered in baskets over 1,400-foot cliffs. In one day, they constructed ten miles plus fifty feet of rail line.

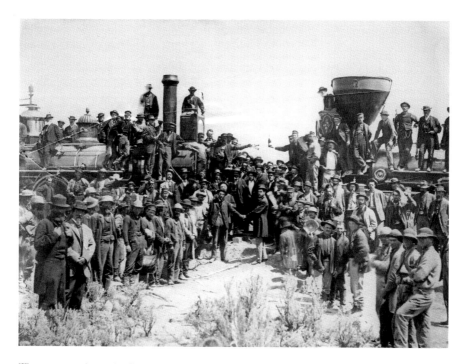

The transcontinental railroad was completed at Promontory Summit. Although twelve thousand Chinese laborers comprised nearly 90 percent of the workforce, little mention was made of their efforts. *Utah State Historical Society.*

Central Pacific's success was ensured by the work ethic of the Chinese laborer. Yet, after the completion of America's first transcontinental railroad in 1869, these immigrants were derided by politicians, labor unionists and unemployed whites who faced a recession and feared the Chinese would inundate the West with cheap labor. One hundred years later, their achievements were all but overlooked.

That many Chinese were literate and capable of rising above the ranks of labor held no sway.

Historian Ronald Takaki notes that the Chinese were "strangers from a different shore" who quickly became undesirable and unequal aliens. Their lot was blatantly characterized by the term "Chinaman's chance," meaning no chance at all.

Such anti-Chinese sentiment pushed Congress to ratify the Chinese Exclusion Act of 1882, deferring Chinese labor immigration for ten years, but it came to be viewed as ineffective. The more punitive Scott Act passed in 1886, followed four years later by the harsh Geary Act.

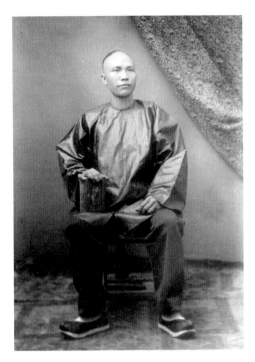

Sam Wing, circa 1885, was a prosperous merchant and autocrat of China Town in Silver Reef, Utah. *Special Collections, Marriott Library, University of Utah.*

Allowing only for children of citizens, university students, established merchants and emissaries, these directives tried to stem America's Chinese population growth. Until the laws' dissolution in 1952, many Chinese entered the country as "paper sons" of fictitious relatives.

Family names were bought and sold, and biographical information was learned by rote. The interrogation process was comprehensive and arduous. "[A paper son] would have to know the layout of 'his' village, how many bridges it took to get to a crossroad, which way the buildings faced, which streets went east to west, or north to south, and whether he lived in the middle of the village or at the end," explained Utah restaurateur Ed Kim. "Then he would use his inability to speak English to hide things that were not obvious."

Salt Lake City architect William Louie grew up in Ogden's bustling Chinatown. A fourth-generation Chinese American whose grandfather was an immigrant railroad worker, Louie understood the apprehension of surnames.

"The majority of people came as 'paper sons' terrified of being found out," he told me. "We were aware our Chinese name was different than our American name. To protect us, my father never said how he got here; and as a community, we kept to ourselves."

"The Chinese grappled with racial intolerance, language barriers and few job opportunities," retired insurance agent Bob Louie recently added. "Doors close. You're overqualified, under-qualified. If you've lived as long as I have, you know the signs, but how can you argue?"

Today, eighty-year-old Louie questions society's inequity. "Racism hasn't abated," he said. "Only by getting to know each other might fears dissipate, and we might yet meet as equals."[14]

Chapter 13

"Abstract" Depicts a Regrettable Era of Racial Discrimination

In Barbara Nelson's backyard, quail slip into fall thickets, pumpkins decorate the fence line and tree-ripened pears fall to the ground like confetti. Nelson, imbued with October's radiance of life and harvest, unrolls an old, rediscovered document, an "Abstract of Title," defining much of what is now called Rosslyn Heights.

It was striking to learn that in 1855, our neighborhood was part of a 160-acre "bounty land" granted to "officers and soldiers engaged in the military service of the United States." It was a sucker-punch to read that no part of this bounty in 1936 could be "sold, transferred, granted or conveyed to any person not of the Caucasian race" and that the covenant would exist for twenty-five years before becoming "null and void."

In 1847, black pioneers joined the handcart movement traveling westward. By 1850, nearly eighty-five African Americans lived in the Utah Territory. Some were free blacks. More were slaves of southern whites who had joined the LDS church.[15]

Utah's black population totaled 118 by 1870. Most African Americans worked in Salt Lake City or headed to Ogden; others homesteaded farmland in Union Fort, Murray, Cottonwood/Holladay and on Evergreen Street.

In 1886, 584 "buffalo soldiers" of the U.S. Ninth Calvary were garrisoned at Fort Duchesne on the remote Ute Reservation. A decade later, some 600 U.S. Twenty-fourth Infantry soldiers with wives and children arrived at Fort Douglas and quadrupled Utah's black population.

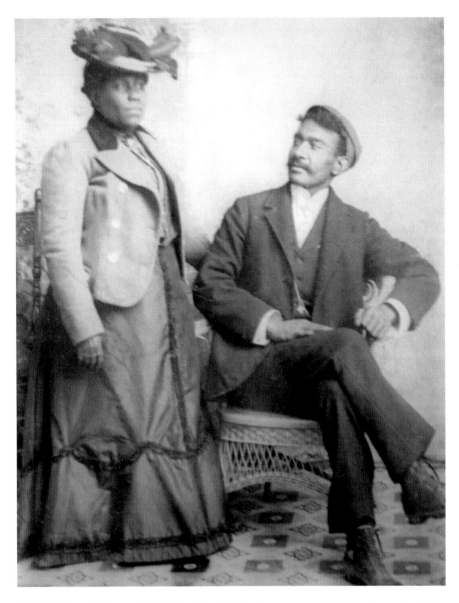

Celia Bankhead Grice and Mr. Grice. The Bankheads were an early black pioneer family in Utah. *Utah State Historical Society.*

Isolated in their "American Siberia," the buffalo soldiers were rarely seen in the city. The highly regarded Twenty-fourth Infantry was more visible and, according to historian Ron Coleman, faced discrimination by a white populace that "believed in white superiority and black inferiority."

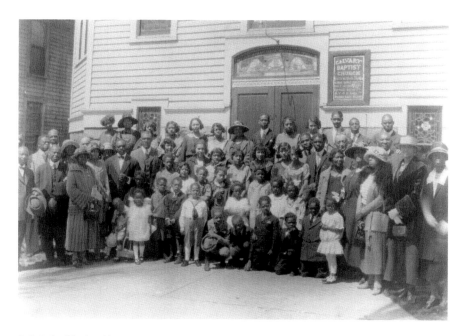

Salt Lake City's African American community at the Calvary Baptist Church, founded in 1892. *Special Collections, Marriott Library, University of Utah.*

Editorials warned of potential infractions and disturbances. Soldiers were forbidden to leave the fort without wearing a uniform. They couldn't apply for additional work off base. Despite such bullying, Coleman said the infantry's presence and professionalism "influenced the social and cultural life of Salt Lake City's African-American population."

By the 1900s, the black community had well-established churches, political associations, social and fraternal organizations and newspapers. The *Western Light*, edited in 1914 by James McAdams, was published "in the interests of the colored race," affirming "justice if possible, peace at any rate."

In 1914, seven-year-old Doris Steward Frye and her eleven siblings lived on Third North and paid a dime to ride the streetcar to Calvary Baptist Church. At Fremont School, she "was the only black child in that room" and was often taunted.

"The children were prejudiced," Frye said. "They didn't take kindly to black people. They resented us, treated us like dirt and called us names. One time, my dad said, 'Don't be antagonistic unless it's absolutely necessary for you to defend yourself, because even in a place like this you might get the blame, [just by] being black.'"

In 1914, Frances Leggroan Fleming lived on Evergreen Street, where her parents raised chickens, rabbits and pigs and grew potatoes, peas and beans.

"We had everything we needed," said Fleming, a member of the LDS church. "But once you've been marked by prejudice, you don't erase it, and you don't forget."

That discrimination would continue for decades. Interracial marriages were prohibited; access to restaurants, hotels and clubs was restricted; housing was segregated; public accommodations were denied; education was limited; and work opportunities were sorely lacking.

"You could get a maid's job, but there's no way you'd be hired to do any professional work," said Frye, who wanted to become a nurse. "They wouldn't hire black people to do those things then. That was just the way of life."

Doris Frye left Utah to find equity. Returning years later, Frye witnessed changing attitudes and socio-economic achievements. At ninety-two years old, she advised African Americans to "keep on making strides ahead.

"We are all the same family," she asserted, "all the same race."

Today, the "Abstract" pales into the regrettable past. Barbara shares her garden's bounty—the neighborhood ripening in diversity and embrace.

In 2002, Doris Steward Frye died, two months shy of ninety-six years old.

Chinese Immigrants Persevered on Plum Alley

In early 1903, fourteen-year-old Chinese immigrant Y. Henry Gim hid under a sack of mail and rode the rails from Oregon's mining camps to the small town of Mackay, Idaho. At fifteen, he borrowed $115 to buy into an eight-chair lunch counter consignment in the Union Pacific Railroad depot.[16]

Business was brisk. Within two years, Gim repaid his loan and soon married his wife, Louise. After opening a restaurant, he bought a ranch with several hundred acres of land.

"He was hoping to raise beef to use in his restaurant," said his daughter, Helen Gim Kurumada, in interviews archived at the University of Utah's Marriott Library.

When the stock market crashed in 1929, he lost it all.

A harbinger of the Great Depression, the crash cruelly emphasized the economic struggle experienced by farmers throughout the 1920s. Crop, beef and pork prices plummeted. Debts were high. Most farmers were mortgaged to the hilt, and few banks offered relief.

Moreover, companies that controlled irrigation water profited from land grabs and rate hikes.

"They ruined farmers like my father," said Kurumada, who was twelve at the time.

Forced to leave their home and possessions behind, the Gim family traveled to Salt Lake City. The train ride "was like a funeral train. Everyone was crying and worried," she said.

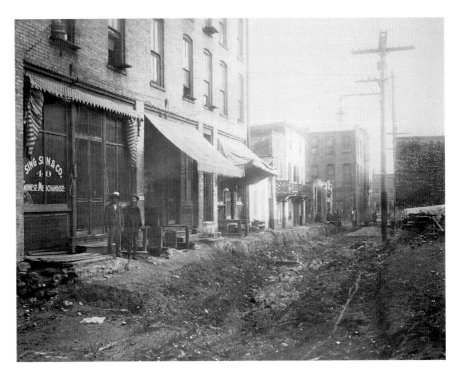

In 1907, 1,800 Chinese lived in Plum Alley. During the Depression, it was a place of worry for the Kuramadas. *Special Collections, Marriott Library, University of Utah.*

The Gim family was helped by "Chinese clan obligations," but their Plum Alley apartment in downtown's Chinatown was far from home and in poor shape.

"My mother grew depressed," said Kurumada. "She worried we would starve."

Reassuring her otherwise, Henry quickly found a business partner. He opened the Bon Ton Café on 100 South, and the family settled into a new life.

While some twelve thousand Chinese immigrants helped build the Central Pacific railway from Sacramento, California, to Promontory, Utah, during the 1860s, the International Panic of 1873 fueled anti-Chinese sentiment among labor unionists, unemployed whites and politicians. By 1930, few jobs were offered other than those associated with restaurants, laundries and groceries. Inequity was public.

"Our parents paid taxes, but we couldn't go to city swimming pools," Kurumada said. "We would have to sit in movie theater balconies."

During a school trip to Wasatch Springs, it was only after a teacher intervened that Kurumada was allowed in with the manager's warning: "Don't you ever try this again."

One evening after work, Gim sat in his rocking chair. He asked Kurumada to boil water for tea, remarked he was tired and died. Shortly after, his widow suffered a fatal nervous breakdown. The children were sent to live in a blue-collar, non-Asian home in which Kurumada said her foster parents "tried their best, but their three boys felt it was a disgrace to have 'Chinks' living with them."

Appalled, Kurumada knew something had to be done and espoused her father's "can-do" philosophy. After graduating high school at sixteen, she found employment through the Works Progress Administration (WPA) program, rented a small house on the west side and took charge of her three siblings.

"I was definitely underaged," she said, "and in hindsight, I marvel that Judge Reuben Clark allowed me to take care of my brothers and sister."

Cautioned about monthly visits from Children's Services, Kurumada made certain everything and everyone was in its place and tidy. "My younger sister Betty was always spotless," she said. "I thought if I took her down to Neighborhood House and she seemed unkempt, they'd say, 'This girl looks terrible. Her sister brings her down, but heaven knows how they live.'"

Betty was six at the time. The boys were in college and home on weekends. And Helen fell in love, marrying Dr. Jun Kurumada. She said the kind man married "the whole dang family."

Y. Henry Gim would have been proud. Against all odds, his children did just fine.

Chapter 15

A Minority Child in Magna, aka Ragtown

Lately I've been thinking about stories, the kind told by people I've known over time—such as those lived by the Matz siblings: Berenice, Ruth and Sidney.[17]

"Magna used to be called Ragtown by old-timers maybe because the town was built up from nearby tailings from the mines," Sidney Matz said in interviews archived at the University of Utah's Marriott Library shortly before dementia robbed him of recollection.

"My dad, Sam, owned the Fair Store," he said. "He added numbers in his head faster than an adding machine, spoke Russian, Greek and Italian, and won every arm-wrestling contest in town saying it was a matter of leverage."

During the Depression, if Sam saw a "kid wearing raggedy shoes or going barefoot, he'd call him into the store and give him a new pair," his son said. "He said when they grew up and worked at Kennecott, they'd know where to come and buy their shoes. He gave away hundreds."

Sam Matz was born in Russia at a time when Jews were restricted to living in designated areas, forbidden to own land and victimized by violent pogroms (riots against Jews) supported by the authorities.

Wanting more for his children, the elder Matz sent his oldest son, Aaron, to South Africa, where he opened a shipping business. When Sam turned thirteen, his father encouraged him to join his brother. Sam did and, after several years, became smitten with travel. He sailed on cargo ships bound for China, India and Egypt. He then went to Montreal, bought a wagon and horse and peddled his way westward to Vancouver and south into Idaho. There he met Annie Fogel.

Little Sidney Matz with his dad, Sam, in their shop, the Fair Store. *Berenice Matz Engleberg*

"When my dad met my mom, he must have wanted to make an impression because he arrived at her parents' house by motorcycle," their daughter, Ruth McCrimmon, told me.

"It was around 1914. He took her for a ride in the countryside, and during their trip, she fell off the motorcycle. He didn't know until he turned around to talk to her. She wasn't there! Backtracking, he found her sitting by the side of the road. She must have had a good sense of humor because they married soon after."

By 1922, the couple and their three children had settled in Magna, a mining boomtown brimming with ethnic diversity.

"The Papanikolas kid and I played all the time. The shoemaker, Shorty Notarianni, watched over us," Sidney said. "Many Kennecott officials were Masons. They respected my dad. If people wanted jobs in the mines, they were told, 'Go see Matz, he'll get you on.' He'd call the hiring boss, they'd get on, and trade in his store."

"Our house was welcoming," Berenice Engleberg later told me. "Mother made the best rye bread you ever tasted. Dad regaled everyone with stories told in his South African accent. Sidney, too, had a way with words. We

had great times putting on vaudeville shows in front of the store. But it was difficult being a minority child."

"I was six and Berenice was eight when my father's friend, a [Mormon] bishop, [invited] us to Sunday school," Ruth explained. "As soon as we entered the classroom, the teacher told everyone that Jesus was the Son of God—and accused us of killing him.

"I whispered to Berenice, 'We didn't do it. Who did it?' She said, 'Well, Mama didn't do it. She's too nice. It must have been Dad.' I said, 'Why would Dad do a thing like that?' Berenice said, 'I don't know, but I think he did.' Out of all of us, we figured Dad was the only one who could have done it."

When Sam heard this, he called the bishop, who was appalled. And when I last visited Berenice in 2008, the ninety-two-year-old said the teacher's remark haunted her for years.

"We were kids," she said. "What could a kid say to that?"

Black Miners Encountered Danger and Racism in Utah

From 1916 to 1930, more than one million African Americans left their homes in the South to find employment in the North. In 1922, when economic and political upheavals in the coal mining industry ignited nationwide strikes, blacks were brought in as strike breakers, and a small number were "imported" to Utah.

Some worked in the mining communities of Peerless, Scofield, Kenilworth, Castle Gate and Latuda. Seven miles west of Helper, Howard Browne's stepfather toiled in Rains, which opened in 1915 and employed as many as two hundred men.

"Black miners went wherever they saw a chance to get a job, and drifted from one mine to the next," said Browne in family interviews archived at the University of Utah's Marriott Library. "I remember twenty black people living in bunkhouses in Rains while white people lived in homes below."[18]

Howard Browne was born in Kansas City in 1911. His grandfather was a doctor. His father, a first lieutenant in World War I, was a lawyer whose career was limited by segregation.

"He was appointed to the state auditor's office," Browne said, "but never got the chance to practice law."

After the war, Browne's parents divorced. Howard spent summer vacations with his mother in the coal mining camps of Carbon County and attended school in Kansas City. In 1929, he enrolled at the University of Kansas as a pre-med student and married his college sweetheart, Marguerite. But

his education was cut short by the throes of the Great Depression and his mother's urgent plea.

"She was a conservative woman. She took in people's laundry, brewed beer for sale to bachelors and saved enough money to buy forty acres of farmland in Carbonville." Browne explained. "Then her [second] husband got sick and she needed my help."

Seeing that his mother did not have a house to live in, he built one. He dug a compact ten-foot, hole-in-the-ground structure, felled a large pine tree in the mountains and spliced it to form a pitch for the roof. Lashing smaller trees to the beams, he overlaid the substrate with tarpaper and dirt. He then cut an opening for a stovepipe and built stairs to the front door.

Finding a home of their own was made more difficult because, Browne's wife acknowledged, "no one would rent houses to blacks." For several years, the family lived in rented chicken coops "half the size of a 'normal' living room."

Browne farmed in summer and mined in winter. He dug ditches, "opened up dog holes in the side of the mountain," laid rails, worked on his knees and hauled coal. At twenty-eight, he finally said he'd been around mines "long enough" to read the signs.

"The most dangerous times in a mine are when the tides of the ocean come in. Very few people believe this, but when the tides come in, they move mountains way up here in Utah," he said.

Then he tells what happened while mining in Spring Canyon in 1939.

"It was near noon. We were at the end of the property, pulling back pillars, propping up timbers, and shoveling coal onto a conveyor when I heard the roof and floor crackling—when they say the mountain is 'working.' You can tell by that 'popping' sound something's going to happen real quick."

Grabbing his shovel, Browne raced toward the portal. The superintendent couldn't persuade him or the others to stay.

"He said nothing was going to happen before morning," Browne said. "I said by tomorrow, I wasn't going to be there."

The mineworkers were topside eating lunch when suddenly the "whole thing came down. The machinery, the drills, the main [entrance]—everything—went down," Browne said. "That superintendent just wanted to take the chance [by keeping us working].

"And I told him, 'You son of a bitch, you tried to get me killed! You can have your mine!'"

Survival bound, the following summer Howard Browne moved his family north to Salt Lake, where a red cap future on the railroad lay in wait.

PART V

Rails, Wires, Wheels and Roads

Chapter 17

Pony Express Riders Met Perilous Western Trails

It was 1860. The gold rush was at its peak. Thousands of eastern prospectors, miners, entrepreneurs and settlers were carving out new lives in the West. The vast Utah Territory still encompassed Utah, parts of Wyoming, Colorado and much of Nevada. And civil war was imminent.

The U.S. government, fearing western secession and alliance with the South, wanted to counter political unrest and bias with ongoing, up-to-date national news. Distant relatives wanted to hear more often from home. Although Congress had established postal service to the Pacific coast in 1847, overland stagecoach delivery was simply too slow.

To connect East and West with improved communication, efficiency and speed, three western freighters—William H. Russell, Alexander Majors and William Wadell—introduced a spirited transcontinental mail delivery relay system they called the Pony Express.[19]

Promising mail deliveries within ten days, the businessmen mapped a 1,966-mile route and designated some two hundred stations that were being built or refurbished along the way. They also introduced custom-designed mochilas stitched with four separate padlocked leather mail pouches. Thrown over the saddle, the leather mochila was cut to accommodate a saddle horn and cantle and spaced for a rider's legs.

Departing from St. Joseph, Missouri, their route followed the Oregon-California Trail along Nebraska's Platte River and through South Pass, Wyoming. At Fort Bridger, though, riders would divert from the emigrant trail, head south of the Great Salt Lake and due west across the salt desert to the Sierra

Nevada Mountains toward Sacramento, California.

Large home stations were staggered seventy-five to one hundred miles apart to house riders and horses. Every ten to fifteen miles, riders would switch horses at smaller relay stations. Before Congress reduced the territory of Utah in 1861, sixty-five stations marked the territory's route from Pacific Springs, Wyoming, to the California border.

As stations, corrals and stalls were being built, the firm hired four hundred station keepers and assistants. Broadsides advertised positions for youthful riders: "Wanted: Young, skinny, wiry fellows not over eighteen. Must be expert riders, willing to risk death daily. Orphans preferred."

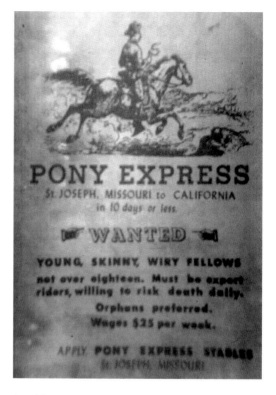

An old poster calling out for pony express riders—had to be young and expendable. *Special Collections, Marriott Library, University of Utah.*

The trails were perilous; nerves of steel were a prerequisite. But legends were in the making when eighty fearless young men were hired on, each weighing less than 120 pounds and able to carry 25 pounds of equipment and 20 pounds of mail on horseback. Riding day and night no matter the weather, riders were paid up to $150 a month to relay U.S. mail across "inhospitable wilderness" and were given two revolvers and a knife for defense.

The first Pony Express trek was initiated on April 3, 1860, at 7:00 p.m., when the "grimy and grand" Missouri locomotive engineer Ad Clark pulled into St. Joseph's railroad station after a 206-mile "treacherous high-speed" run from Hannibal to hand over the first load of mail.

At top speeds, riders raced to each relay station, switched horses and, grabbing their mochilas, rode on within two minutes. Mark Twain described the exchange as a "whiz and a hail."

California mustangs were often used for the western trail, Kentucky and Utah Territory thoroughbreds for the eastern route. Many horses exhibited an uncanny sense of direction and were known to carry a rider through disorienting salt storms and raging blizzards. Or not.

En route to Utah's Mountain Dell station, rider George Edwin Little got caught in a heavy winter snowstorm. His horse gave out. Cutting open the locked pouches and tucking the mail inside his shirt, Little left the horse behind and broke trail on foot.

Reaching one station by morning, he rode bareback to the next, Old Salt Lake House, and delivered his charge. His rescued horse was "none the worse for the ordeal."

On October 24, 1861, the country's coast-to-coast telegraph system was up and running. Two days later, the Pony Express business was shuttered for good.

In the 1800s, the Telegraph Connected a Nation Divided

Faster than lightning and foreshadowing the Internet, on October 24, 1861, when the "wire rope express" from America's Pacific and Atlantic coasts connected midway in Salt Lake City, the transcontinental telegraph line electrically united the nation during a time of secession, Civil War and change.[20]

That day, amid telegraph key clacks and sounders, California chief justice Stephen J. Field dispatched the first transcontinental message to President Abraham Lincoln declaring the state's loyalty to the Union and its people's "determination to stand by its government on this its day of trial."

Brigham Young, president of the Church of Jesus Christ of Latter-day Saints, sent the first message from the Main Street station in Salt Lake City: "Utah has not seceded but is firm for the Constitution and laws of our once happy country."

Almost instantly, overland telegraphy became part of the American experience. And just as quickly, it eliminated the perilous 1,840-mile Pony Express service that sped westward from St. Joseph, Missouri, to California within ten days at great cost to young riders.

Telegraphy dates back to thirteenth-century England and Roger Bacon's experiments with magnetism. In America, transmission of electric impulses became practical in 1840 when Samuel Morse patented a single-wire telegraph system using the "dits" and "dahs" of his telegraphic alphabet, the Morse code. In 1844, he sent his first electric telegraph message, "What hath God wrought?" from Washington to Baltimore. By 1850, urban telegraph lines linked with neighboring states.

In 1860, Western Union Telegraph Co. and its consolidated associates sought and won a ten-year federal contract with an annual subsidy of $40,000 for building and maintaining the telegraph system. The Pacific Telegraph Co., under Edward Creighton's supervision, would expand the line west from Omaha, Nebraska. The Overland Telegraph Co., led by James Gamble, would head eastward from Carson City, Nevada. Both men placed bets on who would arrive first in Salt Lake City.

The work, begun in late May 1861, was laborious; the obstacles, many. Civil War requisites hampered the acquisition of workmen and supplies. Although Creighton's crew covered more miles, the more western terrain proved formidable.

Wire and glass insulators, ordered from the East and shipped by sea around Cape Horn, had to be freighted by wagon train across the Sierra Nevada.

"The train was very long, the road narrow, and many of the wagons too heavily laden for mountain roads," Gamble recollected in the 1881 issue of the *California Magazine*. "It made slow progress and frequently blocked up the road, delaying incoming trains as long as a day at a time."

Departing on May 27, 1861, the estimated twelve-day journey across the mountain took nearly a month.

Locating telegraph poles was also a constant challenge. Telegraph companies relied on local contractors knowledgeable about their country's resources.

Thousands of poles were hauled in, distributed and erected along the six-hundred-mile route from Carson City to Salt Lake City. "As there was not a stick of lumber in sight, it seemed at first a mystery how they were to be procured," Gamble wrote.

He was relieved when Young contracted to supply "200 miles of poles for the eastern section of the line from Salt Lake west."

But Young's contract with suppliers failed. Gamble wrote that the leader "denounced the contractors who agreed to furnish the poles from the pulpit saying [such] work should and must be carried out. The work was entrusted to other parties."

By October, sixty miles remained to be completed between Ruby Valley and Schell Creek. Allaying fears of late-winter logging and impending storms, Gamble joined the work crew and ascended a mountain near Egan Canyon. Reaching the timber by sundown, they set up camp under a cold, heavy sky.

"Rouse out! Rouse out!" Gamble shouted, awakening to six inches of snow. The snow quickly melted. The crew returned, timber in tow. But they were late.

Creighton won.

No matter, the line was completed, and boy, oh boy, how that wire hummed.

Chapter 19

Utah Women Left the House to Tap "Talking Wire"

As soon as Samuel Morse tapped out his famous electronic telegraph message from Washington, D.C., to Baltimore, another electrifying spark was heard loud and clear. Telegraphers were wanted. Women could apply.

In the early 1840s, during the Industrial Revolution, approximately 20 percent of America's workforce represented women working outside the home in factories and mills. New England's textile trade alone employed eight thousand young women and girls.

Many put in thirteen-hour workdays. They boarded in cramped, company-owned houses; toiled amid the noisy clatter of mill looms and spindles; and breathed stifling air charged with floating particles of cloth filaments and threads.

Despite such unhealthy working conditions and low wages, economic independence for women seemed within reach. But when the "talking wire" connected the nation in 1861, meeting midway in Salt Lake City, telegraphy offered women a better chance for equity (although wages fell below those paid to men), education and independence.[21]

Tying into the east–west transcontinental telegraph line, LDS Church president Brigham Young proposed to build the Deseret Telegraph system, connecting the territory as far north as Bear Lake and south to St. George. Telegraph stations soon opened on main streets, appeared in rural parlors and bundled into railroad depots.

Since many Utah women already held nontraditional roles in ranching and farming, they took up the key easily and were rarely seen as a threat

by male co-workers. Barbara Gowans and Emily Warburton of Tooele attended Brigham Young School of Telegraphy, where key and code were taught and literacy and handwriting skills were essentials.

Sixteen-year-old Maude Matheson became both operator and manager of her post in Cedar City. (She remained long after Western Union purchased the Deseret line in 1900.)

In *The Story of Telegraphy*, Utah historian Kate Carter wrote that many female operators learned on the job, supplemented their families' incomes and passed their knowledge from one generation to the next.

Anne Barnes Layton, a telegraph operator for the Utah Central Railroad in Woods Cross, inherited the post from her sister, Mary Ann.

"I never missed one roll call which was at 8 a.m.," Layton wrote in memoirs archived in Carter's book. "My salary was advanced three times. I clothed and boarded myself and gave my mother $10 each month and helped clothe my youngest sister Sarah."

The only operator at the station in 1879, Layton shouldered telegraph equipment, railway and telegraph forms, one flag and a red lantern for signaling trains. During one windstorm, she spent eighteen hours helping clear the tracks of derailed and blocked cars.

Layton often worked long hours "until the last train cleared," she wrote. "You could send ten words in a telegraph for a flat fee. When the train stopped, passengers would run to the telegraph office, write their telegrams, pay the flat rate, and rush back to the car. I didn't have the time to count the words until the trains had gone. I had to do a lot of condensing, but I never omitted the essentials."

In 1884, Layton resigned to "marry the man of [her] choice."

Mary Ellen Love, who used Estelle as her "wire" name, worked at Fountain Green during the 1862 Black Hawk War. In Mona, she was an operator for the Deseret line while clerking at a general merchandise store. Maintaining contact with her sister telegraphic operators, "Lizette" Claridge and "Belle" Parks from Nephi, she married and continued transcribing Morse code transmissions in Dry Creek while rocking her baby in her lap.

Defying the convention that females were high-strung and incapable of handling demanding technical work, many female telegraphers deciphered code in their sleep.

Once, longtime cattle rancher and former telegrapher Katherine Fenton Nutter ordered railroad cattle cars. Hearing the operator clacking in Morse code, she pulled him up short, saying, "I said *cattle* cars, not *sheep*."

Ogden Tunnels a Reminder of Rip-Roaring Past

S he must have been around six years old when Linda Kunie Oda, née Inouye, first discerned gaming tables, chairs and a tunnel in the dimly lit basement of her parents' Kay's Food Market on 227½ Twenty-fifth Street in downtown Ogden City.

"It was a small space and the word was during Prohibition it had been a speakeasy," the current director of Utah's Office of Asian Affairs told me. Lighting or alarm systems were rigged to alert patrons to potential raids.

"As soon as they heard the warning, they'd move quickly through the tunnel towards the alley and disappear. But that was years ago," she said.

Perhaps. But then as now, the network of underground tunnels and its many adaptations on Ogden's Two-Bit Street are part and parcel of the city's historical legend and memory.

From a small rural settlement built within four forts, Ogden incorporated in 1851 and developed commercially and with a legacy of diversity. Mormon leader and Ogden's first mayor, Lorin Farr, founded the town's grist- and sawmills. Pioneer David Burch established wheat mills along the Weber River. Entrepreneur David Eccles introduced his lumber mill. The Kuhn brothers ran wholesale dry goods and clothing enterprises. Industry developer Fredrich Kiesel became Ogden's first Gentile mayor in 1889. On the outskirts of town, Japanese farmers cultivated Sweetheart celery and the world-renowned Everbearing strawberries.

In 1869, Ogden hefted another mantle onto its western shoulders. When the nation's first transcontinental railroad—built on the labor of Civil War

Black porters and waiters on the Union Pacific in Ogden were required to have their own hotel and restaurant facilities. *Utah State Historical Society.*

veterans, Irish immigrants and indentured Chinese—rolled into Union Station, the city became a railroad town, and Two-Bit Street rolled out the red carpet.

Hordes of travelers disembarked daily at the junction of Wall and Twenty-fifth Streets to whet their appetites on Two-Bit Street. A segregated town at the time, black railroad workers, red caps and waiters often stayed at Anna Belle Weakley Mattson's Porters and Waiters Hotel, which charged twenty-five cents a night, accommodated more than fifty men and later offered free board and room to black students attending Weber State College.[22]

Among the fine restaurants, hotels, saloons, ice cream parlors, barbershops, rooming houses and Chinese laundries, society's shadier element set up business above and below the surface of the city.

"Two-Bit Street was all about liquor, prostitution, gambling, looting, corruption and drugs," Scott VanLeeuwen said one day while giving me a tour of his shop.

The proprietor of the Gift Shop, Ogden's oldest pawnshop on Twenty-fifth Street, specializing in guns, gold and diamonds, VanLeeuwen said, "When you've got guns, girls or whiskey, it doesn't take a lot of imagination to figure out what to do with a network of tunnels and underground rooms."

Subterranean gambling halls, opium dens, cribs carved into tunnel walls and speakeasies called iron door clubs were prolific, profitable, in contact with escape tunnels and undiscriminating to Ogden's gentry and its working class.

Childhood memories churn in recollections of Chinese mobsters and members of the Tong, a secret society, who lived, worked and died beneath Twenty-fifth Street. They summon up murals, gunnysacks and colored pictures plastered on dissident brick and cement walls flying in the face of law and order. They relate tales of bootleggers who built and operated stills in the tunnels and made underground rum runs between Union Station and the Ben Lomond Hotel. Some even remember the Egyptian Theater's 150-foot-long exit tunnel that ran westward one hundred feet, jogged toward the east and uphill 50 feet more beforoe spilling into the back alley.

In a town rife with anecdotes and urban myths, who can say what really happened?

"I don't think there was a tunnel between First Security Bank and Union Station," VanLeeuwen said. "With streetcars running up and down the street, you'd think at least one would have been torn up and discovered."

VanLeeuwen defined most tunnels as street-level coal chute channels that ran the length of many buildings. Then he showed me his.

Descending a steep set of stairs into a reconstructed dirt cellar that spanned several buildings, we passed a regiment of rifles and some exquisitely hand-tooled saddles. It was dusty and dark, but off to the side heading toward the back, a tunnel boarded up and rigged with an alarm stood out from the residue beckoning to be remembered.

Chapter 21

In 1890s, Utah's Women Found Freedom on Bicycles

During a recent pollution-free morning in Utah, I took out my bike, pumped air into the tires, grabbed my helmet and cruised the neighborhood feeling free as a bird.[23]

Somehow—blame it on fresh air—I got to thinking about the evolution of cycling. From the wooden "boneshaker" and the high-mount "ordinary" to the modern "safety" bicycle, wheels have not only impacted our roads, but they've also steered our social mores.

In 1877, Columbia Manufacturing Co. produced one of the first American-made bicycles at the Weeds Sewing Machine Company in Hartford, Connecticut. High-mounts sold for $125; sewing machines, $13.

By the 1890s, the Golden Age of cycling was in full bloom. Nationwide bicycle sales surpassed two million. Cyclists formed the League of American Wheelman (and later lobbied for better roads). Newspapers regularly printed "Wheel Notes." Sports pages regaled readers with tales of wheel races, cycling rivalries, long-distance excursions, adventures and woes.

In Utah, agile wheelmen caught the fever fast, and enterprising merchants seized the moment. Browning Bros., Salt Lake Hardware Co., Western Hardware Co. and Continental Market sold the latest in safety bicycles.

Bicycle manufacturers, such as Meredith Brothers (the 1888 forerunner of Guthrie Bicycle Co.), went into full production. Bicycle riding schools offered lessons. In 1896, 2,500 Utah bicyclists took to the road—many of them on the safety.

The safety—which featured smaller, equally sized wheels and rear-wheel drive—was a less expensive and popular alternative to the perilous ordinary

with its fifty-two-inch front wheel. Although the sixty-inch high-mount guaranteed great distance covered with each pedaled revolution, remaining perched on it was risky. "Taking a header" (being thrown over the front wheel) was both common and painful.

The innovative safety bicycle, with its lower-to-the-ground frame, offered competitive speed and engendered no class distinction. Phasing out the high-mount, the safety offered equity to the masses, opportunity for the modern woman and, during the 1890–1920 Progressive era, was a shoo-in for the suffragist movement.

"Let me tell you what I think of bicycling," abolitionist and suffragist leader Susan B. Anthony said in 1896. "I think it has done more to emancipate women than anything else in the world. It gives women a feeling of freedom and self-reliance. I stand and rejoice every time I see a woman ride by on a wheel…the picture of free, untrammeled womanhood."

According to Sue Macy's *Wheels of Change*, suffragist Elizabeth Cady Stanton, age eighty, supported increased mobility and road improvements. In an article for the *American Wheelman*, she wrote, "The bicycle will inspire women with more courage, self-respect and self-reliance and make the next generation more vigorous of mind and body; for feeble mothers do not produce great statesmen, scientists and scholars."

Early sightings of female cyclists provoked public accusations, ranging from issues of immorality, poor health and bad hair to loss of femininity. The *Salt Lake Tribune* of August 23, 1896, reprinted a *Chicago Chronicle* article adamant in its assessment that "a woman beginner is the terror of the road. She plunges and [wobbles] from curb to curb with a charming indifference to wheelmen and pedestrians alike, and cautious riders invariably turn down side roads at her approach."

If a wheelwoman became proficient and was "as fully able to take care of herself as any of the sterner sex," her sensibilities came into question. "The trouble seems to be that she won't do it," the article informed. "She will ride upon the wrong side of the road. She will cut between two riders going the same direction, and she will dispute the right of way with anything from a baby carriage to a locomotive."

Dress reform sparked rabid debates on feminine morality, unhygienic saddles and sexual arousal. Especially when the restrictive clothing of the 1890s—whalebone corsets, voluminous petticoats, cumbersome dresses, tight waistbands and collars and long sleeves—gave way to practicality: pedal pushers née bloomers.

What was the modern woman to do? Pedal.

Chapter 22

Drive Across United States Bridged Gender Gap

L ast week, while backing the car out of the garage onto our narrow driveway, I noticed my husband square his shoulders and give me that look. It reminded me of June 9, 1909, when twenty-two-year-old Alice Ramsey, her husband's two "conservative" sisters and an eager teenager showed up at the Maxwell-Briscoe Motor Company on Broadway in New York City.

Their goal was to complete an all-female, cross-country road trip from Broadway to San Francisco within two months—traveling 3,800 miles northwest through towns like Buffalo, New York; Chicago; Sioux City, Iowa; Cheyenne, Wyoming; Salt Lake City; and Reno, Nevada.[24]

At the time, most automobiles were costly and driven by men. Social critics believed women were too nervous to handle gas-driven vehicles and physically unable to turn a crank or make a quick decision.

Moreover, female independence on the road could lead to trouble in the home.

The aim of Maxwell-Briscoe (and the automotive industry) was to promote horsepower rather than horse drawn, employ more workers, produce more cars, lower prices and attract an all-gender middle class by proving that "ordinary" woman were capable drivers.

Alice's country lawyer husband, John Rathbone Ramsey, loved the idea.

With Alice as the sole driver—her journey chronicled by pilot cars—reality advertising took to the road in a dark-green, four-cylinder, thirty-horsepower, 1909 Maxwell DA touring car.

The $1,500 vehicle was equipped with bench seats; spare tires; tools; block and tackle; a luggage rack; carbide gas driving lamps; side curtains; a

celluloid windshield; a detachable and durable roof made of Pantasote, an imitation leather material; and a series of state directions.

At the onset, it was a downpour. The women wore rubber ponchos and clutched wet bouquets of pink carnations. Forswearing the need to tote guns or pillows, they posed for a crowd of spectators, photographers and newsmen. Anxious to depart, Alice kissed her husband and started the car.

"Cranking the engine was always part of the motoring adventure," Alice wrote in *Veil, Duster and Tire Iron*. "It was a clash with an unpredictable temperament; a gamble with a possible broken arm."

The young wife navigated slick roads until she reached Buffalo's dry clime. The foursome dined at the Park Club. They toured Niagara Falls. Near Ashtabula, Ohio, they followed directions to turn left at a large yellow house that actually had been repainted green by a farmer with an anti-automobile attitude. Nonetheless, they reached Chicago, where the weary women traded their dusters for ankle-length city clothes, treated themselves to a novel "dry" shampoo and rested.

It was tense crossing the narrow wood-planked bridge strung high above the roiling Mississippi River. Sioux City roads were pocked with holes. Poor road conditions, breakdowns and long repairs stunted their travels to Vail, Iowa. When Maxwell's right rear axle broke outside Grand Island, Nebraska, a replacement had to be freighted in from Denver.

Throughout miles of mishaps involving washouts, swamps, dry gulches, deep ditches, steep banks, arroyos, potholes and unmapped terrain, Alice stayed the course. She forded a stream, traversed over private land and drove her companions safely into Cheyenne for a fine stay at the Inter-Ocean Hotel, followed by bed bugs in Opal.

Outside Utah, Alice met former SLC mayor Ezra Thompson and his son motoring in their new Pierce-Arrow. She followed them through the scenic wonders of Weber Canyon into Salt Lake City. After hearing the Tabernacle Choir and floating on the Great Salt Lake, the women plotted the desert stretch to Reno beginning with a picnic in Grantsville.

Somewhere on a "squirmy trail," the Maxwell smacked into several prairie dog holes. Alice wrote the "front wheels were spread apart" and the "spring seat had broken away from the axle."

Under pilot crew tutelage, she wired together the pieces and motored slowly to Orr's Ranch in Skull Valley to await repairs.

Then the ordinary woman turned the crank and took the wheel. She ate dry cereal in Fish Springs and with verve endured every calamity. On August 7, Alice, her companions and Maxwell arrived in San Francisco ready to return home.

Chapter 23

Lincoln Highway Had Its Own Long, Rocky Road

Several weeks ago while driving painstakingly slowly on gritty back roads to view the migration of swans, I thought about America's love affair with mobility—and Indianapolis Speedway founder Carl G. Fisher, who said motorcars would travel only as far as they "had good roads to run on."

The year was 1912. The automotive industry was mass-producing affordable cars for the middle class. More than 700,000 automobiles were on the road, and good roads were rare. Fisher—manufacturer of Prest-O-Lite headlights—envisioned a paved coast-to-coast highway that spanned thirteen states from New York to California, including Utah.

The charismatic entrepreneur believed the nearly 3,300-mile-long road, which became the Lincoln Memorial Highway, would be kind to car chassis, delight motorists, increase tourism, bring more products to market and boost the country's economy.

In 1913, Fisher and other like-minded industry men with deep pockets established the Lincoln Highway Association (LHA) and set about making this $10 million dream a reality.

The LHA gleaned from the Good Roads Movement, founded in 1880 by the League of American Wheelmen. It created elaborate publicity campaigns, pursued state and local funding and held meetings that drew in huge crowds across the country. An estimated five hundred people (including Utah governor William Spry) attended a rousing rally held at Lagoon.

"These gatherings were as important in the West as everywhere," LHA treasurer and author Jesse Petersen told me recently from his home in Tooele.

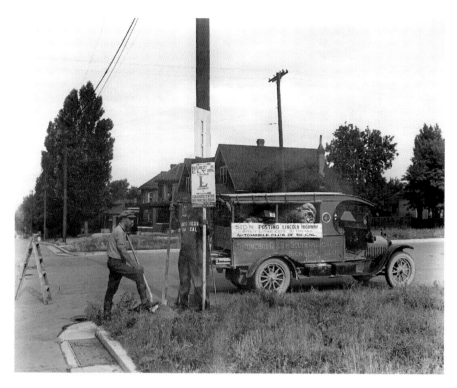

Members of the Automobile Club of Southern California install Lincoln Highway signposts as it paves its way across the country. *Utah State Historical Society.*

"People had cars, rural roads turn to mud in winter, dust in summer, and it was difficult to go anywhere."[25]

To prove it could, the association staged "Seedling Miles" exhibitions.

"They'd get local cement companies to donate concrete and build a nice, mile-long, two-lane concrete road just outside a town," Petersen said. "The idea was once people drove on those sections and saw how wonderful it was to have a paved road, they'd ask their representatives to get involved."

Matching LHA funds with state-provided labor, Lincoln Highway's 1913 proposed Utah route followed Indian pathways, the Mormon trail, the Overland Stage line and the Pony Express.

Crossing state lines in Wyoming, the road went through Castle Rock, Echo, Coalville, Wanship, Kimball Junction and SLC to Grantsville, Fish Springs, Callao, the old Gold Hill and Ibapah toward Ely, Nevada.

Some of these routes rattled Spry, who persuaded the association to travel northward from Echo and Weber Canyon to Ogden before going to SLC.

For eighteen months, this thirty-six-mile deviation was part of the official route. But after monitoring traffic patterns, the Ogden route was rescinded and the original plan restored.

It was rumored that Ogdenites, miffed by the association's initial rejection, were misdirecting tourists onto other roads.

As highway construction moved westward in 1919, the LHA avoided some of the country's worst road conditions by dropping Grantsville and the northern Stansbury Mountains routes in favor of Tooele, Stockton and Clover. Fisher put his own money into building a road across Johnson Pass in the Onaqui Mountains toward Orr's Ranch.

West of Granite Peak on the way to Gold Hill, a rock-and-gravel causeway was built over mudflats. Salvaging miles by detouring the hard terrain of Fish Springs and Callao, the causeway saved cars from getting bogged down when it rained.

While the LHA scrambled for funds to complete the highway to Ely, Utah dug in its heels for a straightaway to Wendover—on another proposed highway. It didn't take long for all hell to break loose.

Utah highway crews, working on the Goodyear Cutoff, a forty-mile shortcut west of Orr's Ranch across the great Salt Lake Desert to Gold Hill, were seven miles in when the state pulled out of the project.

Blindsided by intrastate politics riddled with threats of lawsuits, infighting and bad publicity, not until 1927 did the LHA "reluctantly" abandon its Ely segment for the road to Wendover.

Today, the Lincoln Highway legacy remains pieces of history.

PART VI

Into the Land

Chapter 24

Basque Immigrants Made Their Livelihoods as Sheepherders

During the 1848–55 gold rush, young Basque men from Uruguay, Argentina and their homeland in the Spanish and French provinces in the Pyrenees Mountains immigrated to California's promising gold fields.

Those who struck it rich invested in sheep or cattle ranches and formed partnerships with other Basques. Some who didn't worked in the mining industry, including at Utah's Bingham Canyon copper mines. Others turned to sheepherding. They avoided being *"txamisuek jota"* (struck by sagebrush), withstood the challenges of inequity and made a new life in a new land.

While raising sheep is an Old World Basque tradition, Pyrenees flocks were often small in number (fewer than one hundred) and kept close to the farm. Large-scale sheep production was another story.

According to anthropologist William A. Douglass, co-author of *Amerikanuak: Basques in the New World*, the Basque knowledge of trailing sheep (by the thousands) was gleaned on the pampas of South America. It was this expertise that distinguished the Basques and proved the most adaptable to the western frontier.[26]

Basque sheepherders worked throughout California, Nevada, Oregon, Idaho, Montana, Wyoming, Colorado and Utah. Representing a minor percentage of western shepherds, an industrious Basque accepted sheep in lieu of wages and increased his own itinerant sheep band while running his employer's herd. By 1880, the Basques had earned the reputation as the finest sheepmen in the American West.

Sheepherding is a lonesome profession filled with unrelenting hours, years-long nomadic transhumance (a "livestock management" technique

in which animals travel hundreds of trailing miles during seasonal grazing cycles), mental deprivation and social isolation.

Alone with his sheep, monthly food drops and occasional visits, the loyal dog was often the shepherd's only companion. The iconic sheepwagon defined his workplace and home on the range.

Before Studebaker standardized sheepwagons in 1889, the first handmade architectural gem on wooden-spoke wheels was credited to Utah sheepman William McIntosh (1880), Wyoming blacksmith Jacob Jacobsen (1883) or Wyoming blacksmith James Candlish and sheep rancher George Ferris (1884).

No two sheepwagons were alike. Most were constructed with four to eight wooden bows and a stretched canvas top. Approximately eleven and a half by six and a half feet with an inside brake lever, hinged windows and a door, compact interiors included a sheet iron stove for heating with coal, wood or cow chips; a cantilevered table; a built-in bed; a coal oil lamp; cupboards; a mess box; bookshelves; side benches with lids that opened to outside bins; and an exterior platform for a water keg and fuel oil.

As sheepherders—and new Basque immigrants—arrived in Utah, Basque hotels sprung up in Price, Bingham Canyon, Ogden and Park City. As with John and Claudia Landa's Hogar Hotel in Salt Lake City, these establishments offered a familiar sense of community with Basque culture, conversation, music and cuisine. They served as meeting places and as a bridge between the Old World and New.

Soon enough, many a solitary shepherd married his Basque bride. The sheepwagon, a temporary honeymoon suite, became home and hearth to the dedicated Basque wife, who worked alongside her husband and helped increase his holdings.

By the 1960s, the sheep industry had waned, and most Basque shepherds had moved off the range. Among their herding traditions and experiences relinquished to history and oral recollection, one such story from Douglass's book reads like an old western.

In early 1930, two Basque men acquiring leases to a hayfield near a Utah town angered the former owner, an anti-sheep cattle rancher. Drunk and threatening to shoot the "Greeks," the rancher entered camp and took aim with his rifle at one of the sheepman but was shot in the back by the other before firing. The shepherd's bullet coursed through the rancher's body and accidently struck the very shepherd being threatened. Both men died.

Anti-Basque sentiments ran high. No charges were pressed, but the mortician refused to bury the Basque. The remaining sheepman held his partner's funeral in the desert and feared reprisal. He set up a decoy camp and wintered some distance away, sleeping "in the darkness as a precaution against an ambush which never came."

Chapter 25

Immigrant Farmers Worked Hard to Cultivate Celery

W hite celery. Dirt bleached. Not as stringy as its green progeny. But sweeter. Fresh. Crisp. A class act. In Utah's agricultural heydays of the 1940s, *apium graveolens var. dulce* (celery) was the crème de la crème of crops rising from the acumen of Japanese laborers who envisioned a future in farming.

Kichibei Matsumori departed Hiroshima in the 1910s for San Francisco en route to Utah believing that money could be plucked from trees. "That was his first impression," his son Jim Matsumori told me. After stints of work replacing broken railroad ties and putting in pipelines for culinary water systems, the elder Matsumori set his sights on vegetables.[27]

From the very beginning, most Issei (Japanese immigrants to America) grappled with countless challenges. An 1887 Federal law, still on the books, precluded non-citizens from owning land. The Japanese Exclusion Act of 1924 sorely limited immigration, and unsavory 1911 and 1943 real estate policies discriminated against "members of any race or nationality" deemed "detrimental" to property values.

In response, Japanese farmers rented land on a prayer and handshake that their leases would not be broken by the landlords after successful planting seasons. Eventually, they were recognized as pioneers in truck farming, innovators in vegetable husbandry and profitable investors in Utah's growing fields.

Growing everything from cauliflower, dry onions and broccoli to white celery, Jim recalls working alongside his parents, double-cropping acreage ("but never celery"), weeding, harvesting and bunching vegetables for

sale. He describes colorful scenes of downtown Salt Lake City's vigorous grower's market filled with hundreds of stalls, fresh produce, farmers, trucks, truckers and green grocers bidding on goods to trek throughout Utah and surrounding states.

It was then that the esoteric white celery created a stir and added to the renown of other Japanese-grown celeries celebrated during Utah Celery Week. For years, orders for the delicacy came in from all over the country, and the Matsumoris sent seasonal gift boxes to Utah governor Maw and Presidents Franklin D. Roosevelt and Harry S. Truman.

It was a wonder crop but, unlike most other vegetables, a gamble to grow. Labor-intensive, land-grabbing and complicated, white celery required the fresh chill of northern Utah air, a long growing season, copious water and the right type of heavy, black soil to prevent heartburn and failure.

In spring, the Matsumoris germinated celery seeds in long, deep hotbeds, packed with two feet of manure on the bottom, heated by glass sashes on top and covered at night with straw. The seedlings were then hand-planted every six-to-eight inches in wide rows six feet apart. During September, the Matsumoris piled dirt up the sides of the celery using a two rope–handled, eighteen-inch-wide wooden hoe. "If you freeze the tender plants, they'll bolt—go to seed," Jim explained. "But if you bank them up before the weather cools, you'll cook their hearts."

Mounds of soil were built up creating "trenches as high as two feet from the ground," until the entire crop was covered with dirt, motivating Mother Nature's bleaching process. By mid-November, a crucial time when frost and soil depth combine to sweeten the celery's heart, the plant was dug up and re-buried in deepened rows for late winter harvesting, sometimes accomplished under December snowdrifts.

Using a U-shaped, three-foot blade attached to horses (later replaced by a high-centered tractor), harvesting was done in the blind.

"You listened carefully," Jim said. "The cutter would go along the bottom of the deepest part of the row. If you went too deep, you heard nothing and cut nothing. If you went too high, you'd hear a whining sound and know you slashed your stalks."

Growing white celery is a lost art. Jim, eighty-three, had long turned from cultivating crops to land development. Yet sitting in his South Jordan home, you can see him in the fields, listening.

"When you hear that *swoosh-swoosh* sound," he said, remembering, "you'll know you've done it right."

Chapter 26

Early Jewish Farmers Try Their Hand in a Hardscrabble Land

Picture this, because it is here that one of the largest Jewish agrarian colonies west of the Appalachian Mountains stood ground and failed not for lack of trying. It is marginal land: sparse trees; low-hugging sagebrush; grass, thin, more lean than green; and ground more dirt than soil, much of it unyielding.

Imagine, on a straightaway from Gunnison, what once was Clarion, an early Utah farming colony composed of immigrant Russian Jews instilled with the belief that "agriculture will make laborers instead of paupers, bread producers instead of bread beggars."[28]

Between 1880 and 1920, two million Eastern European Jews immigrated to America's urban cities. Poor and overwhelmed by crowded streets, sweatshops and slums, some yearned for greener pastures. They would listen intently as activists such as Benjamin Brown praised the virtues of farming and back-to-the-land efforts sweeping across the country.

They learned that by working together as self-sufficient farmers they would also further the Jewish economic future of America, help combat anti-Semitism and create goodwill among Christian neighbors.

As Brown traveled the circuit soliciting money from prosperous East Coast and Salt Lake City investors, the colonists borrowed "down payments" from family members and purchased six thousand acres of land; ten dollars an acre, 10 percent down, ten-year balance due.

In 1911, twelve émigrés led by Brown entered Sanpete County anxious to clear land, plow, plant, harvest and cultivate a new life for a community that eventually numbered nearly three hundred Jews. These would-be farmers from

myriad backgrounds greeted each sunrise with "song and labor" and every sunset with "restfulness and spiritual happiness." By fall, they had cleared 1,500 acres for spring planting and were ecstatic at the first sign of greening.

If cities are schools of hard knocks, farms are lessons in harder rocks. Strong winds, dust storms and lack of water wiped out Clarion's first crop. When the state finished its long-promised canal, its poorly constructed banks breached and water leached into other people's soil. Repairs left the colony without a drop of water for thirty-three days. Later, lockless canal gates made it easy for neighbors to pilfer the water.

City slicker Abe Sendrow turns western farmer harvesting with hope in Clarion. *Eileen Hallet Stone.*

Yet, life went on. The second year saw the colony divide into individual farms, each with 4 acres and a house. Trees were planted, wells dug, a school/synagogue built and 2,400 acres seeded.

This time, the colonists faced not drought but deluge. Overnight, heavy rain coursed down hills carrying rocks, branches and debris. By daylight, the growing fields were gone. Frost wiped out a later crop. Their cistern broke; they patched it. And still tragedy. Crops withered, tempers rose and resilient hearts sank.

An infant died and was buried in Clarion. Then Aaron Binder, a most respected farmer, died when a fully loaded wagon toppled over and crushed him. By 1915, fifty members had departed; three families remained up until the 1920s, and then they, too, left.

Japanese would find their way to Clarion, and then Mormons, neither for long.

Clarion is a ghost town, hard to locate but important to find in order to understand the courage of these farmers and their impact on American Jewish history and Utah life.

On a cloudless day, I walk a small knoll toward the middle of nowhere and stumble upon white pipe fencing, small bouquets of plastic flowers and Hebrew inscriptions on two western tombstones: Clarion's Jewish cemetery.

Cracked hardpan stretches as far as the eye can see, and I'm alone with a newborn and immigrant farmer. Suddenly, dust clouds billow. A cattle stampede? Tense, I stand my ground. Motorcycle. Man. Cowboy with hat and wearing jeans. Gotta be a movie.

Bruce Sorensen, a local farmer sensitive to the past—"We share the same history," he said—explores Clarion with me. Piecing together broken walls, school foundations, paths, sites and artifacts, we unearth reality.

It's dry country. "Even today, we fight for water," he says.

Following family traditions, on Memorial Day, Bruce places flowers on the graves. I nod my head to history and find a dusty agate that buffs to sheen.

PART VII

Uniquely Utah

Chapter 27

From Bucket Brigades to a Pumper Called "Roosevelt"

As early as 1853, Salt Lake City depended on volunteer bucket brigades, dedicated individuals from local wards, private homes and commercial businesses, to put out fires, save lives and protect property.

Upon hearing shouts, whistles or the city hall bell tolling an alarm, these brave volunteers would stop on a dime, pick up their leather buckets and wooden ladders and race like their feet were on fire in continuance of their motto: "We Aim to Aid and Work to Save."[29]

In 1856, a more formal volunteer fire department came into being. Its appointed chief engineer, James C. Little, and his crew had built the city's first hand-pumped fire engine, dubbed the "Volunteer." Reconstructed twice over time and towed by strong men with ropes from the engine house to burning sites sometimes as far as a mile away, the mighty engine was capable of directing a stream of irrigation ditch water four stories high.

When fires burned two houses and a dozen barns, concerned citizens, including insurance agent and secretary of the territory Samuel Mann and New Movement Godbeite member Henry W. Lawrence, purchased a new steam fire engine from Silsby Manufacturing Company.

It was bigger than the first, and the men who pulled it had barely enough energy left to fight the flames. In 1875, the Silsby failed to quell the fire at Salt Lake City banker Warren Hussey's First National Bank of Utah, resulting in $200,000 worth of damages.

In *Fire Departments of Utah*, compiled by Kate B. Carter for the Daughters of Utah Pioneers, volunteer firefighter John Cardwell described a November 1879 fire in the Clift House in downtown Salt Lake.

Cardwell and a cohort were on the second floor dousing the flames when a water-drenched adobe wall caved in, trapping them. Tightly holding onto the fire hose for safety, Cardwell felt the firefighters below struggling to free the presumably snagged and uncoupled hose. Unaware of the men's dilemma, he heard them yelling, "What's the matter with that doggone hose?"

In the thick of smoke and water, Cardwell unscrewed the nozzle and, using the hose as a speaking tube, shouted down loudly enough to be heard and rescued.

After midnight on June 21, 1883, a fire started in H.B. Clawson's Wagon Depot at the corner of Main Street and South Temple. Within moments, the blaze struck Clawson's stash of illegally stored gunpowder kegs and set off an explosion that consumed his property, wooden crates, machinery and wagons.

Walker Brothers and Utah Central Railroad volunteers worked feverishly to contain the raging firestorm. No. 2 Engine Company volunteers Charles Feveryear and Brig Randall were blown off a roof. The blast shattered windows. Airborne particles spread, its embers briefly igniting the Tabernacle and Tithing Office rooftops.

Charles Savage's Art Gallery, Sorenson & Carlquist's furniture store, Scrace's Bakery, Morris's headstone shop, two shoe stores and a print shop were all but destroyed. Save for standing stone walls, the Council House was demolished along with the *Women's Exponent* newspaper office. Losses exceeded $92,000.

Clawson, Brigham Young's son-in-law, was deemed responsible but never held culpable.

Four months after the firefighters petitioned for raises, city council instituted a paid department. Overseeing forty "call men," the last volunteer chief, George Ottinger, became the chief of the Salt Lake Fire Department. In 1892, the "call men" were replaced with service crews. That year, the department recruited fire horses and responded to 146 alarms.

In 1902, the city purchased a 10,800-pound, nickel-plated stack and hardware, horse-drawn steam pumper for $8,900. Painted maroon and bright red with gold leaf details, leather seats, red-trimmed wheels and iron tires, it had all the bells and whistles.

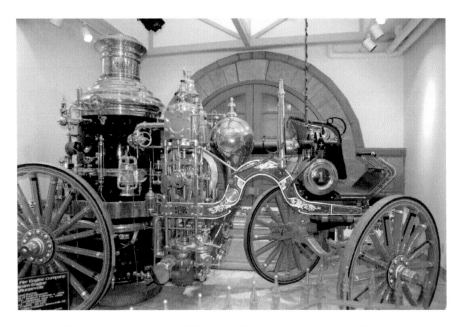

Wheels of the pumper. *Photographed by Eileen Hallet Stone at the Daughter of Utah Pioneers.*

Dubbed "the Roosevelt," the pumper was fifteen feet long and over nine feet high, with a ninety-two-horsepower, coal-fired boiler and was capable of discharging one thousand gallons per minute at one hundred pounds steam pressure.

Pulled by horses instead of men, it changed the firefighting milieu forever.

Chapter 28

Plenty of Booze in Beehive State Until Prohibition

As early as the 1850s, "spirits"—distilled alcoholic liquors—were infused in Utah life and history. The enigmatic Orrin Porter Rockwell, personal bodyguard to Brigham Young, U.S. deputy marshal and zealous religious enforcer, operated the Hot Springs Hotel and Brewery near Point of the Mountain in 1856. He also kept company with Valley Tan whiskey, a "potent potable" that late historian and *Salt Lake Tribune* journalist Hal Schindler described as "invented and manufactured only in Utah."[30]

Spirited ads and editorials led to a liberal read in Salt Lake City's short-lived (1858–60) *Kirk Anderson's Valley Tan* newspaper. Miller, Russel & Co. advertised "outfitting goods, hats, cigars, mushroom catsup, and hardware," along with "cognac, brandy, Monongahela whiskey, bourbon, and port wine."

The successful Valley Tan whiskey produced by the "Messrs. Mogo and Burr tasted first rate." And for the "accommodation of travelers," dining rooms were offered at the brewery while "an attentive hostler" took care of animals.

Thirty miles south of Cedar City at "the base of a mountain capped with black lava rock," bejeweled vineyards in Toquerville provided more than enough grapes in the 1860s for master vintner John C. Naegle to produce sacramental wine for LDS church members.

Naegle built a handsome rock house and winery, taught the colonists the art of winemaking and installed a wine cellar large enough for wagons to turn around in. The fermented juice was stored in five-hundred-gallon casks and transported in forty-gallon barrels to Zion's Co-operative Mercantile Institution (ZCMI) and its branches. Toquerville's wine business was big

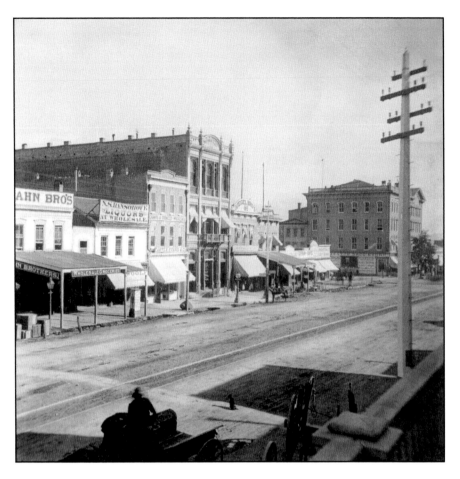

N.S. Ransohoff and others open for business in early downtown Main Street, SLC. *Utah State Historical Society.*

business. In 1864, Jewish immigrant and freighter Nicholas Ransohoff, a leader in the territory's only Gentile (non-Mormon) political party, advertised "the highest prices for gold and gold dust." He also sold imported liquor at wholesale prices in his Salt Lake Main Street store and in Corinne and Ogden.

When it comes to the beer brewing process, it all begins with water, hops, yeast and barley and ends with malting, mashing, boiling, fermenting, aging, finishing and, ultimately, kegs and bottled beer.

German immigrant Henry Wagener took beer—ales, porters and stouts—to a new level. In 1864, the twenty-six-year-old built Utah's first major commercial brewery at the mouth of Emigration Canyon. Originally called the California

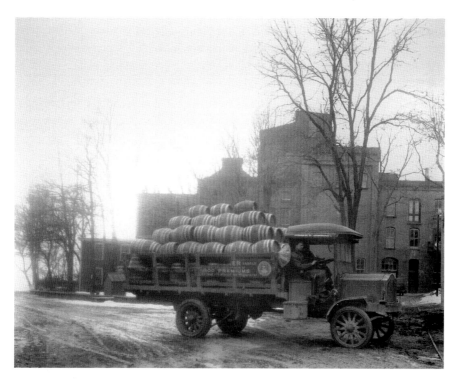

A Wagener Beer truck parks by the brewery in Emigraton Canyon, where a natural spring makes "pure brewing water." *Utah State Historical Society.*

Brewery, Wagener's enterprise was touted as the "Brewery in the Mountains" with beer "as pure as the breath of spring and as delightful as the rays of the noon day sun." Located on a 152-acre site at the mouth of Emigration Canyon, the nearby natural spring offered a continuous source of gravity-fed pure brewing water. A contingent of thirsty federal soldiers billeted less than a mile away at Fort Douglas supplied a willing customer base.

When the Utah Central Railway made its first run to the brewery, the October 28, 1888 *Salt Lake Tribune* reported the "first whistle ever blown in Emigration Canyon blows at his brewery at 2:35 p.m." Faster than a team of horses, the railway shipped in carloads of coke, barley, empty kegs and bottles and transported finished beer for export to markets in Idaho, Wyoming, Montana and Nevada.

As more railroads worked with breweries, icehouses were built along the tracks to supply fresh ice for cooling down beer cars.

In 1874, German-born Jacob Moritz redesigned a small brewery down the road from Wagener's. This new brewery soon produced some six

thousand barrels of beer a year. After negotiating with various partnerships and corporate names, Movitz upgraded equipment, increased personnel and invested in new technology.

His 1885 in-house ice-making machine—a first in the West, he claimed—churned out one hundred tons of ice daily for chilling beer cellars. By 1917, his four-story Salt Lake Brewing Company was considered the largest as far west as California.

In an anti-liquor movement that very year, Utah, among other states, embraced statewide prohibition. By 1920, the Eighteenth Amendment had been ratified, and Prohibition was a done deal nationally. Manufacturing, selling and transporting alcohol was illegal.

Speakeasies, bootlegging and illegal home brewing sprouted into society. Respectable breweries turned to producing sodas, selling ice and waiting for signs of repeal.

Chapter 29

Before Refrigerators, Ice Was Harvested for Utahns' Iceboxes

When technical advances in ammonia-compression refrigeration caught on in the mid-1900s, America's love affair with the renewable extractive industry, otherwise known as ice harvesting, melted. But I'm getting ahead of myself.

It was on the drive through the town of Circleville on Highway 89 that Robert and Lorna Lay's off-white, wood-weathered icehouse caught my eye.

We know ice has been used for chilling since the Chinese created blocks of it in 1000 BCE, and twelfth-century Richard the Lionheart licked frozen sherbets sent by the sultan of Syria. In the eighteenth century, long-term food preservation usually involved methods of salting, pickling, spicing, sun drying or smoking. Still does.

Yet by early 1800, numbers of icehouses insulated with hay partnered with frozen lakes and streams. Hand-sawn or horse-drawn cutters ploughed fields of ice. The United States emerged as a leader in cultivating, harvesting, cutting, "barring," storing and transporting freshwater ice on a commercial scale. And the natural product became a domestic must-have across America, including the small towns of central Utah.

Circleville, founded in 1864, is the childhood home of Butch Cassidy. With a population of 492, it has a historic livestock trail, zero surface water and Robert Lay's faint memory of his father's friend harvesting ice three miles north of Junction.

"I was a tiny boy," he told me, "but I remember going down to the Piute County Reservoir where this old guy, Pete Rick, sawed blocks of ice as thick

as eighteen inches out of the reservoir and peddled them around town." The iceman also harvested enough to refrigerate a commodity-stocked, windowless room next to his own grocery in Junction.

The late historian Dortha Davenport, a neighbor of Rick, noted that ice harvesting was an annual event among the men of the community.

"During the coldest time of the winter, the men would put up ice from the reservoir," she wrote in *History of Junction and Its People*.[31] "Cut into two-foot blocks, they'd haul them to town by team and wagon, store them in sheds with snow packed tightly between each block, and cover them in two feet or more of sawdust. The ice usually lasted the entire summer."

To save on purchasing ice during early spring and fall, some foods were kept inside wooden boxes "nailed on the north side of the house, covered with burlap sacks, [and] wet down several times a day."

Milk and butter were hung with "ropes down dooryard wells." During the hottest months, perishables were kept in iceboxes—well-insulated wooden (or porcelain) cabinetry with nickel-plated hardware and separate compartments for ice and food. Designed as side or overhead icers, each distributed perfect circulation that prevented food spoilage.

Mechanical refrigeration went into production in the 1920s. The first units sold for $600 but were reduced to $275 by 1930. Sears' catalogue marketed a Coldspot for $40 less. "Still, many of us couldn't afford it," said Davenport's daughter Joanne Thompson. "We used the icebox until nearly after World War II."

By 1950, 80 percent of American farmers had gone "modern." Refrigerators did away with iceboxes. Natural ice harvesting became nostalgia.

In 1943, the Robert Lay's father built the family business and taught his sons to cut meat. Robert stayed on. Their icehouse, equipped with electricity, served a greater cold storage need.

"No one had room in their home refrigerators to put up whole meats. So we'd slaughter, cut and process farmers' whole beef or pork and put them in individual lockers for their keep," Robert explained. "We had one room that was clear frozen, and a chill room for aging meats."

"My husband would do the cutting," Lorna emphasized. "I'd do the wrapping. It was hard work, standing on your feet all those hours."

It was a good business. Nonetheless, when home freezers became a household staple, "they didn't need us," Robert said. In 1968, he closed shop and went into trucking.

Chapter 30

Back in the Day, Utah Boasted Its Share of Ladies of the Night

PART ONE: A NOCTURNAL CIVILIZATION

As early as 1857, when W.W. Drummond, a family man and an associate justice of the Utah Supreme Court, brought his strumpet Ada Carroll to work, introducing her as Mrs. Justice Drummond, prostitution has been part of Utah's frontier life.[32]

Drummond met Ada while trolling the fleshpots of Washington, D.C. After abandoning his wife and children, he was eventually exposed and expelled for his scandalous behavior. But within a year, several brothels were already up and running near Camp Floyd, the short-lived garrison in Utah County, and after the completion of the transcontinental railroad in 1869, there was no holding back one of life's oldest professions.

Whether called prostitutes, ladies of the night or of the calling or simply soiled doves, by the 1870s, these women tendered a robust business in the red-light district of Commercial Street in downtown Salt Lake City.

Located between 100 South and 200 South from Main to State Streets, parlor houses and cribs stretched out among legitimate businesses, tobacco shops, liquor stores, saloons and cafés. Second-story rooms over these enterprises were rented out nightly to prostitutes, who would sit on the stairways and invite potential clients to "come up and visit."

In refined parlor houses run by madams, however, there were no displays of public solicitation. One rang an electric bell for admission, was greeted

by a well-tailored attendant and was escorted into an elegant room dressed in plush red fabrics, draperies and gilded mirrors.

John Held Jr. worked as a newspaper cartoonist for the *Salt Lake Tribune* and moved to the East Coast, where he gained national recognition for his illustrations and block prints depicting America's Jazz Age and the flapper period. He had a chance to glimpse this "nocturnal civilization" while accompanying his uncle on calls to repair gambling machines.

"It was said that the elegance of these palaces surpassed the lavishness of even New Orleans," wrote Held in published memoirs. "This was probably hearsay, as a gold or silver miner's or a cattle or sheep man's idea of elegance was moot in the extreme."

Ada Wilson, one of the city's earliest madams, operated a luxurious parlor house including a "professor" and his piano in the drawing room. She also took daily rides in a splendid, hackney-drawn dogcart.

Helen Blazes, a more conservative madam, accommodated the wealthy and served only wine at her establishment.

In 1908, crews built a stockade to replace posh brothels in downtown SLC. Cribs rented nightly to workers for three dollars. *Utah State Historical Society.*

Clients paid dearly for Catherine Flint's prostitutes, food and entertainment. Doggedly working her way into "society," the courtesan paid close attention when items of Brigham Young's property were seized during the divorce settlement between the LDS leader and his plural wife Ann Eliza.

In the November 2, 1876 issue of the *Tribune*, the "City Jottings" column reported, "It was rumored yesterday that Mrs. Catherine Flint had purchased Brigham's close[d] carriage, and would have his coat of arms erased, and her own substituted."

Business was business, and many madams carried engraved calling cards printed by the Held Engraving Company. John Held Jr., affectionately called the "Mormon Kid," reported the madams demanded of his family's print shop "the finest and most expensive engraving" on the best vellum stock. These cards were smaller than the social standard and difficult to produce by hand from a copper plate. But the run was long, "the money was fresh and there was no quibbling about price."

By 1886, Salt Lake City was a lively boomtown. An estimated six brothels, a series of one-night cribs and numerous saloons and gambling houses inundated the area and so infuriated the townspeople that they rose in protest. The police conducted raids. Clients fled. Prostitutes were arrested, checked for infections and fined.

It wasn't enough.

By 1908, historian Hal Schindler wrote, "There came a hue and cry to 'clean up the city'" and the idea of the "Stockade" came into existence. Out of sight. Out of mind. Still in business.

PART TWO: THE STOCKADES

Prostitution was illegal, tolerated and rife in the business borough's shady backside. By the 1880s, workingwomen had expanded their robust business from the boisterous, cosmopolitan Commercial Street and the adjacent dimly lit Plum Alley to the racially segregated Franklin Avenue and the tenderloin district of Victoria Place.

Within a society choreographed by a subculture of prostitutes, madams, businessmen, bodyguards, politicians and unscrupulous associates, there was no dearth of customers. Eager to support the sale of sex, crowds of miners, ranchers, gentlemen in top hats and everyday Joes haunted the red-light district.

"Occasionally a female figure flits in from one of the side streets and is swallowed up in the darkness of Plum alley," wrote a reporter in the October 15, 1900 issue of the *Salt Lake Tribune*, "and it needs not more than one guess from the uninitiated to tell where she has gone to."

By the turn of the century, the red-light district was in full bloom. "The orchard of Salt Lake's night life was bearing rich golden fruit, and it was easy pickings," John Held Jr. wrote in his memoirs. "Both Sodom and Gomorrah were paying high dividends."

When the townspeople rose in protest, the city's police conducted more arrests, but there seemed no penalty strong enough to stop the tide of prostitution.

"To make any kind of a decent living, I have to take in more than $100 a month," reported a street prostitute in the December 19, 1902 issue of the *Salt Lake Herald*. "I can buy food and coal with it, pay my $60 room rent, pay the $10 a month required as a license [that] the police call a fine, dress myself and have spending money for cigarettes and beer."

When the call to purge the red-light district could no longer be ignored, SLC mayor John S. Bransford was struck by a revelation. Unable to "eliminate" a "necessary evil," the mayor proposed to transplant the prostitutes from the downtown commercial district and resettle them within a stockade. He hired the infamous madam Belle London of Ogden's Electric Alley to oversee the operation.

In December 1908, the brick-and-mortar stockade, located on 400 and 500 West Streets between 100 South and 200 South Streets, was completed. Surrounded by a ten-foot, two-door gated wall, the stockade housed 150 segregated ten- by ten-foot cribs, large brothels, boardinghouses, a dance hall and saloon, tobacco shops, opium dens, restaurants and related businesses on the perimeter.

Each crib, rented nightly to workers for three dollars, had a door and window to call out to customers. Divided by curtains, a washstand and chair were placed in front and an enameled bed in the back.

From the start, the stockade had its own woes, including "secret" entrances, corruption, bribes and deals. "Inmates" were forced to buy from company stores and reside at nearby company-owned homes. Buildings were electrically wired to warn of incoming raids. Reluctant madams and independent streetwalkers were strong-armed to transfer to the stockade or get out of town.

By 1911, the stockade had closed. The red-light district survived.

Interpretations of Western Law

In a remote mountain valley tucked between northeastern Utah and northwestern Colorado along the Green River, "Brown's Hole" represents a nineteenth-century frontier in the American West.[33]

A winter home for the Comanche, Green River Shoshoni, Ute and other native peoples, the region was charted in 1805 by Lewis and Clark and, by the 1830s, foraged by Euro-American hunters, trappers and explorers, including three mountain men who built the Fort Davy Crockett trading post.

Known as "Fort Misery" in 1837, the poorly constructed mud-and-timber garrison was a social hub for mountain travelers and fur traders. When one of the partners stole some horses, the partnership folded. A chase followed. A standoff occurred. The horses were rescued, but the thief escaped, and the abandoned fort quickly turned to rubble.

By the 1870s, the renamed Brown's Park attracted mountain men, ranchers, settlers, immigrants, freedmen (former slaves), homesteaders, cowboys, cattle rustlers and outlaws. It was a melting pot of diversity, a rarity of ethnicity and ethics stirred by personal interpretations of the law.

According to the online BLM Cultural Resources Series on Utah, the Park was also for many entrepreneurs, such as Scottish émigré John Jarvie, a frontier in line with the American dream.

In 1870, twenty-six-year-old Jarvie immigrated to Rock Springs, Wyoming Territory, and bought the Will Wale Saloon. He showcased vaudeville acts, managed a billiard table, sold wholesale and retail liquor and became a U.S.

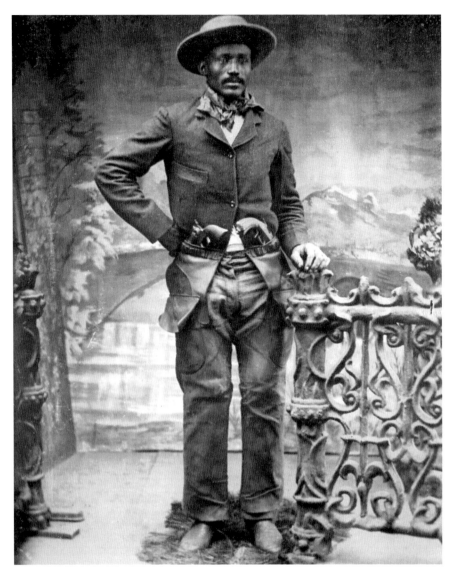

Ex-slave Isom Dart was a well-respected "rider, roper and bronco buster" and possibly an outlaw living in Brown's Park until some ranchers had him killed. *Utah State Historical Society.*

citizen in 1875. In 1880, he married Nellie Barr ("Pretty Little Nell"), who had a lovely voice, and moved to Brown's Park.

The couple honeymooned in a cozy, two-room dugout and later settled in a handsome three-room log cabin. Within a year, Jarvie built the only fully stocked general store/trading post within seventy miles. He sold

merchandise from textiles, corsets, trade goods and gourmet foods—he liked mourning dove pies and Scottish oatmeal—to boots, wagon supplies, Indian flour and saddles.

In 1892, after pouring whiskey from plugged barrels berthed on a raised platform by the sales counter, the storekeeper was charged for selling spirits without a license and taken to court in Vernal. Sampling the evidence, the jury decided Jarvie's whiskey tasted like rotgut. The defendant was acquitted.

In 1881, Jarvie became the town's postmaster. He acquired real estate on both sides of the river, invested in livestock, constructed a blacksmith shop and designed a waterwheel, sixteen feet in diameter, for irrigation. When longtime Park resident and ferry owner Doc Parson died, the congenial businessman stepped in and ran the renamed Jarvie's ferry. He hired operators from the town's list of "colorful characters," touted a shipshape organization and often extended a helping hand over the Green River by accepting farm produce instead of cash.

A well-read man, an athlete who loved to race and a generous host who threw great parties, Jarvie played the organ, recited poetry by Robert Burns and read people's heads (phrenology).

Grieving the loss of his wife to tuberculosis when their youngest child was eight, the admittedly hard-to-please single parent dug his heels in and learned how to sew their clothes.

For years, the family ranch welcomed sojourners just as the dugout provided safe haven for outlaws. Like most Park residents, Jarvie knew many. In 1895, he presided over the town's "Outlaws' Thanksgiving Dinner." It was a formal affair—everyone was dressed to the nines—in which Butch Cassidy served coffee.

On July 6, 1909, the Park's honor code was violated. Mr. Jarvie, who suffered heavy losses in mining ventures, was murdered in cold blood. His trussed body was placed in a boat on the Green River and set adrift.

"What the motive could have been is a mystery," reported the July 9, 1895 issue of the *Vernal Express*. "Possibly he knew too much, as there have been many dark and shady things happen over in the Brown's Park country."

Despite great efforts to apprehend them, the murderers—who absconded with a $100 bill—were never found.

Chapter 32

Newsies of 1900s Used Their Fists to Protect Their Turf

W herever there were newsboys in Salt Lake City, and a need for a rhythmical hawker, there was always my dad," said Richard McGillis, eighty-five, showing me 1910 photographs of Charlie McGillis and an alleyway full of "newsies" wearing wide-brimmed felt hats or slouchy cloth caps and newspaper satchels slung over their shoulders.[34]

The early 1900s illuminated the raucous days of the city's newspaper wars, when the morning *Salt Lake Tribune* and the evening *Telegram* competed with the *Deseret News* for street corners and a tough guy named McGillis was brought in from Denver to establish territory.

Charlie was a son of Jewish immigrants whose surname, misinterpreted at Ellis Island, "could have been Margoles for all we know." He was born in 1889 in Colorado and raised on the mean streets of West Colfax. Five-foot-six, 135-pounds, he relied on his fists for safety and, like so many other sons of poor émigrés, became an amateur fighter.

Dubbed "Chick McGillis, the fighting newsboy of Salt Lake," his "windmill swings and…sheer gameness" had spectators on their feet. Once knocked down and considered out by fans already heading toward the door of the old Manhattan Club, he rose to settle the score and didn't stop there. McGillis, street sales manager for the Newspaper Agency Corporation, was "so tough," Richard said, "if one of 'Charlie's newsboys' had a corner, nobody else would get it!"

But McGillis's strength couldn't hide the unruffled realism about the plight of young newsboys, which led to an alliance and lifelong friendship with financier Russel L. Tracy, who sought to keep them on the straight and narrow.

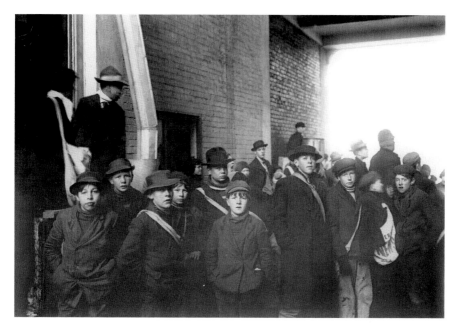

Newsies outside the News Development Room, Salt Lake City, 1908. *Utah State Historical Society.*

In downtown Salt Lake, six- to ten-year-old children hustled newspapers. For some, it was a rite of passage, but for impoverished youth, it was a necessity. Accustomed to purchasing his daily *Tribune* from a street-corner newsie named Ralph Nielson, Tracy, president of Tracy Loan and Trust Company, learned the six-year-old towheaded hawker lost his father and two siblings and was solely responsible for his invalid mother.

Stunned, Tracy was determined "to help young newsboys improve their quality of life," he wrote in his memoir, *Some Experiences of Russel Lord Tracy*. He hosted a series of dinners, but after one outing for seventy-five high-spirited newsboys at Bond's Restaurant turned into a robust food fight, he had his doubts.

That's when McGillis stepped in.

For more than twenty-eight years, the two brawns-and-brains reformers weighed the needs of each newsboy and his family. They provided food, clothing and sacks of coal to get them through harsh winters. They built a gymnasium, held monthly wrestling and boxing contests and organized annual parades.

Prior to the Boys Scouts of America, organized in 1910, newsboy camps in Big Cottonwood Canyon helped "develop characters of honesty, self-reliance, and moral uplift." To keep newsies in school, monetary incentives were offered.

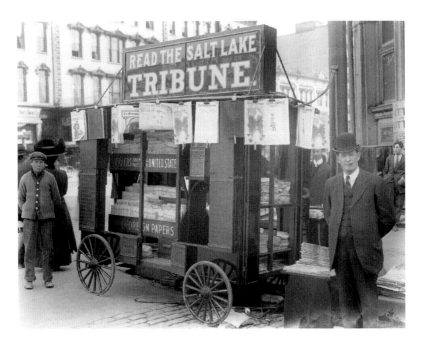

The most complete news wagon, collapsible, easily operated and beckoning for business. 1910. *Utah State Historical Society.*

Scholarly work garnered fifty cents; "very good" gleaned a quarter; and "good" got a dime. (When Ralph turned ten, he got off the streets.)

The federal child labor laws of 1916 wobbled until the Fair Labor Standards Act of 1938 upheld child labor reform. By 1941, the newsies were no more. Some went on to become lawyers and doctors.

The boy who instigated the food fight? That was Herbert B. Maw, the Democratic governor of Utah from 1941 to 1949.

In 1910, McGillis built a unique newspaper store on wheels. Called "the most complete street newspaper stand built" by the *Salt Lake Tribune*, the tidy ten- by six-foot, red-bodied, black-trimmed store on yellow rims secured its corner on 200 South and State. It collapsed into a box by night and opened each morning into an elaborate magazine stand replete with wooden display panels, counters, benches and an electric sign reminding everyone to "READ THE SALT LAKE TRIBUNE."

McGillis, who retired after sixty-seven years in the newspaper business, protected corners, newsies and fighters like Jack Dempsey and Gene Turney, all the while keeping his compassion, his business sense and his promise: "If you've got a home, I have your home paper."

Chapter 33

A Country Newsman Bleeds Printer's Ink

In the early spring of 1912, newspaperman William Perry Epperson and his son, Clyde, boarded the Bamberger Electric Railroad train—heralded for its "every hour, on the hour, in an hour" service—and traveled to Kaysville, Utah.

According to J.M. Cornwell's *Utah Press Association: A Century Later*, the two men had leased a plate-littered, "broken down" paper called the *Weekly Reflex*. Little did anyone know that within weeks, they would stimulate readership by crafting country journalism with a swell of national news.[35]

William Epperson was born in 1859 in Abingdon, Illinois. He graduated from high school at seventeen and trained as a "printer's devil" on the *Abingdon Express*. When the nineteen-year-old tried but failed to publish his own newspaper, he, like so many other youths, headed west.

During the late nineteenth century, Colorado's silver mining industry was booming. Epperson picked up odd jobs in Denver and then traveled south to Colorado City (later known as Colorado Springs), where he took up farming.

He married his sweetheart, Leonora Ash. The couple had two children, Clyde and Estella, and William became active in Colorado City community affairs. In 1888, he purchased a weekly newspaper, the *Colorado Iris*. For the next twenty years, he worked with Clyde, who cut his teeth on metal type, to make it a success.

"The last decade wasn't easy," researcher and director of Layton's Heritage Museum Bill Sanders told me. "By 1893, the silver market was

collapsing, Colorado was in a mining depression, and without jobs, people were forced to leave."

Sanders, whose manuscript, "The Gentiles: Their Life and Legacy," includes history of the *Weekly Reflex,* said the Eppersons struggled to keep the *Iris* alive. Increasing print costs, waning subscriptions and dwindling profits proved too much.

In 1909, news of land speculation and fruit booms in Green River, Utah, persuaded the family to pull up stakes and move farther west. William returned to farming and community life. He helped lead the drive to build a bridge over the Green River and in 1910 worked for the *Green River Dispatch.*

Three years of early frosts and crop losses convinced him that printer's ink was his true calling and sole proprietorship his aim. "If you see a weekly around in Utah that's selling cheap, let me know," he encouraged friends.

The *Reflex* was named to reflect reality. When William took over as editor and managing director on April 4, 1912, the paper was saddled with a $2,000 deficit. His first two issues were like most weeklies: local news and "boilerplates" of ready-to-print copy and revenue-driven advertisements, such as "Lydia Pinkham's Vegetable Compound and various catarrh [runny nose] remedies," the Utah Press Association (UPA) reported.

But Epperson understood the impact and value of news. On April 15, 1912, his publishing acumen was unparalleled.

The day before, the British passenger liner RMS *Titanic* was on its maiden voyage from Southampton to New York City when it collided with an iceberg in the North Atlantic Ocean and sank. An estimated 705 people were rescued; more than 1,500 perished.

Without delay, syndicated news services offered weeklies their reports. Epperson grasped the opportunity to give his readers firsthand accounts about a maritime disaster that shocked the world.

The *Reflex* captured readers' imagination with images, investigative inquiries, tales of courage and stories by those who survived the *Titanic* and of those who died.

The paper's circulation soared, and advertising copy increased. For nearly two decades, Epperson modernized the paper, expanded its home print and highlighted school sports and activities. Winning numerous journalism awards, he was progressive with content and fearless in his editorials.

A city councilman and longtime UPA president, Epperson ran the paper until his death in 1931. In tribute, the *Salt Lake Tribune* reported, "The country press lost a sterling character—a stalwart champion on the public welfare."

PART VIII

Representing a United People

German Immigrant Rose to Become Utah's Only Jewish Governor

Looking back at the life of Simon Bamberger, the German immigrant who not only was elected state senator in 1903 but also became Utah's first Democrat, non-Mormon and only Jewish governor in 1916, I can't help but think how this country's true grit builds the mettle of a man.[36]

Born in 1846, Bamberger immigrated to New York when he was fourteen and from the very start was on the westward move. In Indianapolis, he set pins in a bowling alley. He clerked for his brother Herman in Ohio while the older sibling soldiered in the Civil War. In Missouri, the brothers opened a clothing store, and in 1865, Bamberger ventured farther west to collect an overdue bill.

"We sold considerable goods to a trader following the Union Pacific Railroad as it was being built westward," Bamberger said in 1924 interviews archived at the University of Utah's Marriott Library. "Money was scarce, and the man was [in] our debt."

Crossing the Missouri River at Council Bluffs, the nineteen-year-old went by train to a railroad tie-camp along the Utah border, where, he recalled, "both the life and the men were primitive and tough."

He never found the delinquent salesman and two months later learned the family business had failed.

"Alone and far away from home," Bamberger decided to test his fate.

He gave quick cash to workers for their paychecks, charged them a fee for the transactions and then cashed the checks and pocketed the full value. After gold was discovered nearby, he built tents and shacks to rent to prospectors.

Simon Bamberger's inauguration day, Utah's only Jewish governor. *Special Collections, Marriott Library, University of Utah.*

After Indian raids wiped out settlement, he journeyed to Ogden and took up innkeeping. After an outburst of smallpox kept Union Pacific passengers at bay, he rode the Utah Central to Salt Lake City and bought the Delmonico Hotel on the southwest corner of 200 South and Main. He and Ogden partner B. Cohen renamed it the White House.

Twenty-six years old, Bamberger then turned to mining. He invested in the Sweetwater district of Nevada and in Utah opened up mines in Bingham, the Park City area and Juab County. He reunited with his brothers, Jacob, Herman and Louis, and engaged them in business as well.

After several years, Bamberger was wealthy enough to retire. Yet this redheaded, short, stocky man characterized as stormy, staunch, tenacious and "hardened to opposition" just couldn't resist the challenges of the West.

He put money into Sanpete County coal mines and built a connecting railway system between the mines. When that venture failed—the coal was inferior—he was steadfast in seeking other possibilities. In 1890, he constructed the Intermountain West's first interurban railroad line. It carried passengers from Salt Lake City to Beck's Hot Springs and his newly built resort. Extending the line to Farmington, he transformed swampland into an artificial lake and developed an amusement park called Lagoon. Eighteen years later, Bamberger's railroad line stretched to Ogden.

"In 1908, the road was first run with steam locomotives," he said. "In 1910, it was electrified."

Although Bamberger never received formal schooling, he championed children's rights to a better education and fought to raise teachers' pay. He broke bread with the workingman; sponsored "crop mortgage loans" for farmers; helped establish Clarion, the Jewish agricultural colony near Gunnison; and believed everyone was entitled to a square deal.

A teetotaler, Liberal Party member and Democrat, seventy-year-old Bamberger ran for governor against Nephi Republican L. Morris and won by a twenty-two-thousand-majority-vote landslide. In his inaugural address, he emphasized his endeavor to represent "a united people" rather than "any one religious, social, racial or industrial faction."

A consummate westerner, Bamberger extolled the region's strength. "The West is coming into its own," he said, "and the eyes of the world are being turned upon it for guidance and inspiration. We should therefore take special care to so conduct our government that we may win the admiration and confidence of all other states." His words, still, are true grit today.

PART IX

Suffragists in the West

Nineteenth-Century Mormon Woman Fought for Rights

Nearly a year after the Utah Territory first enfranchised women—the issue of polygamy aside—one can easily imagine the July 2, 1871 dedication of the new Liberal Institute in Salt Lake City when suffragists Susan B. Anthony and Elizabeth Cady Stanton engaged an audience of Gentiles and the "New Movement" group of dissident Mormons also called Godbeites.[37]

Floorboards shook when Anthony declared, "There can be no salvation for womanhood but in the possession of power over her own subsistence." Stanton's delivery on human rights and the health of a nation's future based on self-reliance and science was electrifying.

The short-lived Godbeite movement was founded on political reform, social policy, free enterprise, economic diversification, spiritualism and philosophical debates between traditional religion and modernism.

In 1868, the Godbeites published the controversial *Utah Magazine*, which eventually became the *Salt Lake Tribune*. They also strengthened the Liberal Party in opposition to Brigham Young's authority and religious control. For their efforts, some Godbeites were sent on missions. Some waned in faith, and others were excommunicated.

While in Utah, the suffragists were guests of successful businessman and the new movement's namesake William S. Godbe and his wives. Feeling great affinity for their cause, it was not surprising that several sister-wives were involved in feminism. But who could have imagined that the fourth wife, Charlotte Ives Cobb Godbe, would spend thirty years vigorously advocating

women's rights, suffrage and unity—and become both boon and bane to Mormon Church officials and advocates.

Charlotte was born in 1836 into a prominent Bostonian Quaker family of nine. Seven years later, her mother, Augusta Adams Cobb, deserted her husband and five of their children. Abducting Charlotte and an infant, Brigham (who died), the wayward wife traveled to Nauvoo, Illinois, and married Brigham Young.

Charlotte was brought up in the Lion House,[38] and when she married Godbe in 1869, Brigham Young gave away the bride. Taken by her charm and delighted with her intellect, Godbe admitted his timing wasn't perfect. During this period of marital bliss, he was excommunicated.

By 1873, Godbe could no longer reconcile plural marriage with his beliefs. Recognizing only one wife, Annie, he shouldered his domestic responsibility and remained "protector and friend" to all the others. Divorced in 1884, Charlotte married her first cousin, John Adams Kirby. A non-Mormon, Kirby made their fortune in mining.

Charlotte, a committed women's activist, introduced herself as "an American woman" and member of the Church of Jesus Christ of Latter-day Saints. She encouraged women to "strike hands of fellowship" regardless of personal religion, ambition or gain. She demanded women's right to vote, advocated prohibition of alcohol and spoke of her "belief in spiritual mediums."

Privately, Charlotte acknowledged "painful" experiences being a plural wife. But when invited to speak before U.S. House of Representative committees or national suffrage conferences, she still extolled Mormon ideals and defended polygamy.

Once, among a group of quarreling delegates in Boston, Charlotte recommended separating politics from religion to reach accord. She may have gone too far. Her improvised remarks worried church leaders, who wanted Utah suffragists to help stem the tide of anti-polygamy by promoting Mormon women, lifestyles and goals for statehood.

Emmeline B. Wells, Relief Society leader and editor of the pro-Mormon journal *Women's Exponent*, judged Charlotte inadequate to represent Utah women, unwise and unable to stay within church guidelines. Charlotte responded that women must be informed, vote, hold elective office and help develop laws.

In 1887, Congress rescinded Utah women's voting rights, but Charlotte stayed the course. In a February 17, 1889 *Salt Lake Herald* article, she wrote, "Knowledge is power, and certainly there is nothing unwomanly in the study

of the use of the ballot, so when the time comes that women [have their] rights restored, she may know how to intelligently use them."

In 1890, the Church of Jesus Christ of Latter-day Saints renounced polygamy. Six years later, Utah achieved statehood and, with it, the women's vote—at least in Utah. In 1920, the Nineteenth Amendment to the U.S. Constitution gave all American women the power of the vote.

Suffragist Lobbied in Utah

In Washington, D.C., forty minutes before midnight on April 8, 2011, a government shutdown was temporarily staved off. You could almost hear a nationwide sigh of relief from federal employees as business went on as usual.

But for politicians sparring over debt and social issues, basic healthcare and women's rights seem poised to take the hit. In a rollback to the National Woman Suffrage Association spearheaded by Elizabeth Cady Stanton and Susan B. Anthony, you could have heard suffragist and lawyer Phoebe Couzins asking the House Judiciary Committee in 1884, "What of the woman?"[39]

Born in St. Louis, Missouri, Couzins was the third child of politically active parents. Her father was the chief of police in St. Louis and a U.S. marshal. Her mother, a Unionist and nurse, served in the Western Sanitary Commission tending wounded soldiers during the Civil War.

After graduating from high school at fifteen, Couzins worked alongside her mother, inherited an "activist spirit" and believed that, given the right to vote, women could help prevent the miseries of war. In her mid-twenties, she set her sights on helping humanity by becoming educated.

Couzins didn't break records. She set them.

In 1873, Couzins became the first woman to graduate from the Washington University School of Law and the third to graduate from any law school in the United States. She was among the first women to be admitted to the circuit court bar in Missouri and Arkansas. In 1872, she was admitted to the Utah bar and the federal courts of the Dakota Territory. After her father's death in 1887, Couzins assumed another first for women: serving as U.S. marshal.

But Couzins rarely practiced law. A dedicated suffragist, she used her knowledge of the "legal system and constitutional law" to support arguments for the enfranchisement, advancement, political rights and equality of all women regardless of race or religion.

She spoke without guile and was said to have a "pretty face and feminine mien." The *Missouri Hornet* called her "a women's rights" woman to be proud of. A letter in the *Missouri Republican* described one of her speeches as "an eloquent plea for the broader, fuller intellectual physical development for her sex," and Stanton wrote she moved audiences "to laughter and tears" and "appealed to the heart."

But it was Couzins's understanding of the law's complexity that held their attention, and for a time she traveled extensively with suffragist leaders, addressed large assemblies and lectured on her own in Utah and the West.

Unbridled by eastern society's restrictive cultural underpinnings, western women often did men's work and made independent decisions. Suffrage was a matter of practicality. In 1869, the territory of Wyoming sanctioned "unrestricted" women's suffrage. Utah women embraced equity's call in 1871.

Couzins asserted that, religious convictions aside, "the women are emphatic in condemnation of wrong" and had "accomplished great good."

But suffrage was short-lived. In 1882, Couzins argued against Alabama U.S. senator John T. Morgan's motion to ban Utah women from voting. Eastern suffragists voiced no objections to the disfranchisement of polygamous men, but they decried legislative efforts to deprive women of their rights.

When Congress enacted the Edmunds-Tucker Act of 1887, it prohibited plural marriage by imposing fines and imprisonment, enforced the legality of marriage licenses, replaced local judges with federally appointed ones, obliged public officials and potential voters to take anti-polygamy oaths—and revoked every woman's right to vote.

Only when Utah achieved statehood in 1896 was women's suffrage restored here.

Addressing Congress earlier, Couzins paralleled women's rights with the female "Statue of Freedom" that tops the dome of the U.S. Capitol.

"It was no idealistic thought or accident of vision that gave us Liberty prefigured by a woman," she said. "It is the great soul of the universe pointing to the final revelation yet to come to humanity, the prophecy of the ages—the last to be the first."

So, who's looking up in Washington now?

Chapter 37

Western Women Were in the Thick of the Suffrage Movement

In 1848, one hundred delegates met in Seneca Falls, New York, to participate in the nation's first Women's Rights Convention. They protested the exclusion of women's rights and signed the controversial Declaration of Sentiments, penned by social reformer Elizabeth Cady Stanton.

American abolitionist Frederick Douglass praised the declaration as "the basis of a grand movement for attaining the civil, social, political, [educational] and religious rights of women."

But who would have thought that western women would become the first to embrace the call for equality? In 1869, the territory of Wyoming sanctioned "unrestricted" women's suffrage. Utah's territorial legislature granted women political equality in 1871, Washington Territory in 1883, Colorado in 1893 and Idaho in 1896.

Intrigued, Stanton and fellow suffragist Susan B. Anthony traveled to Salt Lake City in 1871 to see firsthand the enfranchisement of women still eluding the eastern vote. The women lectured on women's rights, equality and plural marriage and drew large crowds at Tabernacle Square, Stanton noted, "until the doors of the Old Tabernacle were closed to our ministrations."

Closed doors and revoked voting rights may have stymied a more timid population, but despite concerns about Mormon political might if Mormon women received the vote, Utah women founded the Utah's Woman Suffrage Association. By 1894, they got their planks onto party platforms and, when Utah achieved statehood in 1896, witnessed women suffrage policies re-written into law.

From 1912 to 1914, Kanab had an all-female town council led by Mayor Mary Howard (center). *Utah State Historical Society.*

But why was the West smitten by women's rights? In *The Woman Suffrage Movement, 1869–1896*, historian Beverly Beeton suggested the western vote "was generally viewed as a privilege not an inherent right" and suffrage a matter of "expediency, not theology."[40]

Suffrage themes were used to advertise the image of the West and its limitless opportunities.

For Elaine Rogers, eighty-four, of Mount Carmel, women's suffrage was a matter of fair play.

"Western women weren't bound by the same cultural restrictions, structures and prejudices prevalent in eastern society," she told me. "Often she had to do men's work, face the unknown and build a culture of independence, which gave her the right to have a say."

In 1912, an all-woman city council was elected by men to run the small farming community of Kanab. "Our election was intended as burlesque," wrote Mayor Mary W. Howard (a pseudonym for polygamist wife Mary Woolley Chamberlain), "[but] we consented to do the best we could."

Mayor Howard and her trustees—Tamar Hamblin, Luella McAllister, Blanche Hamblin, Vinnie Jepson and Ada Seegmiller—tended to town management, church, family and home. Much credited for their work, Howard wrote, they were "discussed in every home for good or ill."

In 1914, Kanab's all-women regime resigned. But western influence led, and women's suffrage had prevailed.

PART X

Working the Mines

Mother Jones Struck Out in Helper—
But Not for Lack of Trying

Say what you will, but you can't keep a good woman down. Like "Mother Jones," the legendary activist, advocate and paid agitator for the United Mine Workers of America (UMWA) who came to Utah in 1904 to "agitate, educate and aggravate" for the fiercest of strikers—those who work the mines.

Mary Harris was born in 1837 in County Cork, Ireland. In her teens, she immigrated with her mother and siblings to Toronto, Canada, where her father worked as a railway laborer. A skilled seamstress wanting more, Mary enrolled in school, became a teacher and taught at a parochial academy in Michigan.

In 1861, Mary met and married George E. Jones, a union iron molder at a local factory in Memphis, Tennessee. They had four children, and life was comfortable.

In 1867, tragedy struck. An epidemic of yellow fever swept through their parish, infecting thousands and killing hundreds. Mary nursed her loved ones amid cries of delirium but suffered the loss of Catherine, five; Elizabeth, four; Terence, two; baby Mary; and her husband, George.

Too bereaved to teach, Mary moved to Chicago, a burgeoning boomtown. She opened a dressmaking shop that attracted well-heeled customers and quickly discerned class distinctions where wealth abutted poverty. Four years later, the Great Chicago Fire of 1871 burned the city—and her shop—to the ground.

Temporarily homeless, Mary spent evenings in the Knights of Labor's fire-scorched building listening to labor movement issues and its struggles. Defying social convention, she became a member and found her voice.

Espousing to "pray for the dead and fight like hell for the living," Mother Jones came into being.

Over the years, supporters praised her as the labor movement's Joan of Arc and the miners' guardian angel. President Theodore Roosevelt called her the "most dangerous woman in America."

Nevertheless, Mother Jones stood up and spoke out to improve conditions for railroad, steel and textile workers; children; and miners.

In November 1903, when the Castle Gate coal miners went on strike against mine owners Utah Fuel Company, 356 of the 474 miners were Italians—immigrants at the heart of Utah's labor force. They sought honest weighing of coal, equitable wages and hours and acknowledgment of the UMWA.

Coal company officials accused the Italians of being "ungrateful foreigners" who instigated the walkout. Most of them were chased out of the mining town. After all, they had been renting company-owned homes on company-owned land.

According to Utah historian Philip Notarianni in *The Peoples of Utah*, newspaper accounts of the strike "left readers with a more intensified,

John and Caterina Bottino family in front of their boardinghouse in Helper, Utah. Caterina hid Mother Jones from the law. *Utah State Historical Society.*

stereotyped image of the Italian immigrant as a bloodthirsty, nonwhite, stiletto-in-hand villain."

Such vivid accounts also left readers with a skewed view of Mother Jones, linking her to an uncorroborated charge (lifted from a scandal sheet) of being a Colorado brothel owner and prostitute who took to drink and was arrested several times.

When she arrived in Helper, Mother Jones quickly joined several Italians to visit union organizer William Price, who was homebound and quarantined for smallpox. Mining officials stalled her from speaking at a scheduled strikers' meeting and tried to isolate her in a quarantine shed. It didn't happen.

Celeste Dalpiaz and Angelo Pilatti found the shed and set it on fire. Mother Jones was taken to the miners' "halfway house," a temporary camp located between Helper and Castle Gate. Surrounded in protective custody by one hundred armed Italians, she inspired them while championing their efforts. She then hid from the law in John and Caterina Bottino's home.

Told of a planned raid on the strikers, Mother Jones stressed nonviolence, suggesting the men bury their weapons.

In the early morning of April 25, the sheriff and his 45-man posse entered the camp and arrested 120 Italians. Herded into boxcars and sent to a makeshift jail in Price, the strikers waited under lock and key until their trial.

Eleven were found guilty of some offense; the others were set free. The strike failed. Mother Jones moved on.[41]

Chapter 39

Italian Immigrants Found Work in Utah Coal Mines

PART ONE: A UNION STRUGGLE

In 1919, eighteen-year-old Vito Bonacci left his birthplace, the Calabrian town of Decollatura in southern Italy, and set out for America, where industrialization, railroad expansion and mining demands for unskilled workers held the promise of a better life.[42]

As early as 1880, emigrants from over-populated, economically strapped and agriculturally depressed regions of Italy came to America to improve their lot. Many arrived as seasonal workers, earning enough money to take back to their homeland and reestablish their businesses.[43]

Some made frequent trips. One was Vito's father, Dominick, who pulled coke, a coal residue used as fuel, in Carbon County's Castle Gate ovens and remarked that he liked the Intermountain climate.

Most, though, arrived in this country to work and live. They sent for their brides, raised families, established Italian enclaves, became an inspiration to others and strove to maintain their language, customs, traditions, religious practices and beliefs.

At first, Vito sifted coke ash alongside his father in a Pennsylvania coal mine. When relatives sent word of work in Utah's Sunnyside Mine, owned by Utah Fuel Company, they headed west. Vito, a union man, knew to keep quiet when hiring on.

"In 1921, Utah was rough. Didn't want unions. If they knew you were a member, they [wouldn't] give you a job," Vito said in interviews archived at the University of Utah's Marriott Library.

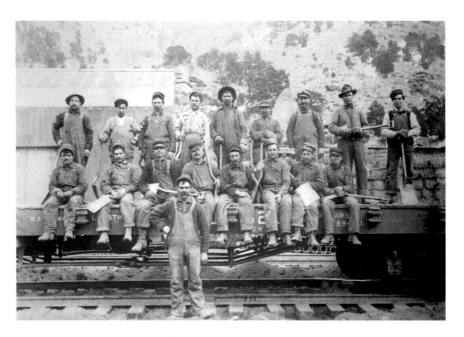

Joe Bonacci, foreman (front, standing) with the Denver and Rio Grande Western Railroad in Helper. *Utah State Historical Society.*

For months, the Bonaccis filled in on the graveyard shift at Sunnyside's coke ovens. "We'd leave the house at eleven o'clock at night and if anyone got sick, laid off or drunk, we'd take their place pulling coke," Vito said.

In the controlled heating process that uses huge, airtight ovens to convert coal into coke, Vito was a scraper. "They would put five or six tons of coal in one oven," he explained. "I'd go over it with a long scraper to [tamp] it off nice and level."

When burned correctly, impurities would be baked out of the coal so it "would come out just like split wood," he said.

Sunnyside coal was reputed both for its "excellent coking properties" and commercial market. In the 1920s, more than seven hundred ovens were turning coal into coke and more than one thousand men were on the company's payroll.

Like most miners, Vito Bonacci lived in a company-owned house. He was given scrip rather than cash to purchase goods at the company store. He was also stereotyped as an "objectionable foreigner." He was not alone. Unprotected by labor unions, immigrant miners suffered discrimination, wage inequity, inadequate housing, bloated rental charges and hazardous working conditions.

According to Utah historian Philip Notarianni, "The realities of tense, sometimes violent struggles between management and labor raised questions [for immigrant miners] about whether freedom and justice existed in Utah."

In 1920, 2,064 union members worked in Utah, where coal companies did not sanction unionization and fired those who actively did. Nevertheless, Frank Bonacci—a relative and neighborhood labor organizer for the United Mine Workers of America (UMWA)—set up numerous "clandestine" meetings to address miners' concerns.

"Many didn't know what a union could do for them," said Vito.

On April 1, 1922, reacting to 30 percent wage cuts, Utah coal miners finally joined a nationwide movement and went on strike.

"Evicted from our company homes, the United Mine Workers gave us tents to live in," Vito said. "We thought we were in good shape until scabs—farmers from Emery and Sanpete counties who knew nothing about mining were trucked in by company men, and made big money."

There was violence. The state militia was called in. When the strike ended, the coal companies restored original wages while rejecting unions. Frank was blacklisted, his family taking the brunt. Having the same surname, Vito struggled for years to find steady work. But together they did help organize Carbon County's coal miners.

In 1933, Utah coal companies accepted the UMWA. In 1936, Frank Bonacci became the first Italian-American elected to the Utah House of Representatives. And Vito remained a vocal union man for life.

PART TWO: FILOMENA FAZZIO BONACCI'S STORY

For years at a time, Rosario Fazzio would leave behind his family and migrate from the Calabrian region in southern Italy to work in the coal fields of Utah.

"My father would be away for five years, come home to Decollatura for a year, and then go back, each time leaving my mother pregnant," Filomena said in interviews archived at the University of Utah's Marriott Library.[44]

"After three children, my mother said, 'I can't live like this any more. If you're going to [America] without us, don't come back.' And my father said he loved her too much to leave her behind."

One of nine siblings, Filomena was born in 1910 in Sunnyside, where Rosario worked in the coke ovens. Wanting to raise his children away from the

mines, though, Rosario bought a farm, ran a dairy and found employment in the nearby Kenilworth mines.

At seven, Filomena said she was "an outside child." She planted gardens and cultivated fields with her mother.

"I'd help cut down four-acre wheat fields with a sickle," she said. "Mother would make a knot with the wheat itself and then tie it to make the bundles of grain. She couldn't read or write, but she sewed, canned, delivered babies, and was good in everything she did."

Filomena recalls the 1922 strike. Evicted from the non-union company town, many miners roomed with relatives. Fearing reprisal, the state militia planted machine guns in nearby knolls and subjected the strikers to constant surveillance.

"Uncle Frank [Bonacci] and his brother moved down to our place with their tents," Filomena said. "At night in the hills, searchlights kept a-going. The company saw everything that was going on, who was here and who wasn't here. I'd go to bed with fear, wondering if they were going to come out and get us, my dad—or my uncles. They didn't, but after my uncles moved, my dad couldn't get any work."

The strike lasted for seven months—the miners' struggle compromised by strikebreakers, mostly farmers who saw profit in the mines. During this time, the out-of-work and struggling family lived on nine dollars from the weekly union fund. They were fortunate to have their farm.

"We'd fill up our small duggy [wagon] with vegetables to peddle in Helper and Kenilworth," Filomena said. "We sold every bit of it, I guess, because we were kids."

When the strike ended, the coal companies restored miners' wages but rejected unions.

Meeting Vito when she was sixteen, Filomena told her mother, "He's such a smart aleck. I despise him." In 1926, they married.

Carrying the surname "Bonacci," Vito had gone from one mine to the next but couldn't get hired on. He worked on a "traveling gang" for the Union Pacific and then gardened for a mine supervisor. Only when the farmers returned to the land did Vito return to the mines.

"I would say a thank-you prayer every night when he came home," Filomena said.

Vito cleaned two-story wooden tipples. He ran a stove track. For fifteen years—until he became a mechanic at Kenilworth—he worked winters and got laid off in summers.

In early 1942, Vito couldn't move his arms or legs.

"He was swollen, in pain, and in bed," Filomena said. "Doctors thought he'd never walk. It was hard. But for four months, I'd put his arms around my neck, get him up, and drag him back and forth, every day, trying to work his legs."

Then, one morning, the vocal union man stood up on his own two feet and went to work.

"He *was* a smart aleck when I first met him," Filomena said. "But I'm not sorry I married him.

A sixteen-year-old bride, they celebrated seventy-two years together before her death in 1998.

Utah Mine Disaster of 1924 Killed 172 Men

Whenever I hear about the March 8, 1924 explosions in Castle Gate mine No. 2, it's the death toll—the 172 names—that gets to me. These men, American and immigrant miners, symbolized the strength, character and international ethnicity of Utah's early coal mining industry.[45]

Those men were killed within a violent, twenty-two-minute conflagration, leaving wives without husbands, children with no fathers and countless parents outliving their sons.

Eighty-nine years later, a reading of their names still cuts to the core.

Joe Ambrosia. Basil Gittins. Louis Gialitakis. Fukuzo Inouye. Samuel Rush Jacoby. John Palioudakis. Ben Mascaro. Aetou Manoukarakis. John McClusky. James Murphy. John Thorpe. Thomas Trow.

Utah Fuel Company's Castle Gate mine No. 2 opened in 1912 in Carbon County's Willow Creek Canyon, and its coal was considered the finest in the region. During World War I, Utah's coal production was aggressive. Jobs were plentiful. By the 1920s, though, its production had tempered.

In February 1924, at the Castle Gate mines, single workingmen were temporarily laid off. Even then it was a fortunate married miner (or one with dependents) who could land an eight-hour shift.

On that cold, fatal Saturday morning, nearly an hour after the miners had begun working, an explosion ripped through the mine with such force that wreckage was spewed nearly half a mile across the canyon. Within minutes, a second explosion took out the wall of the mine's fan house. Twenty minutes later, a third explosion sliced the mine's steel doors from its concrete frame.

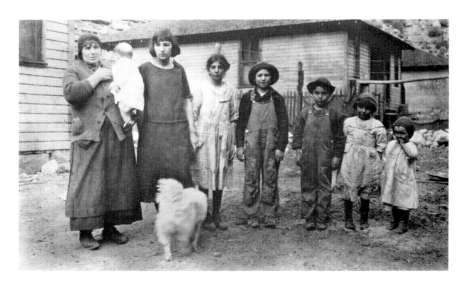

Widow and children of Joe Tellerico, who died in the 1924 mine explosion. The oldest boy is absent here, returning to the mines to salvage his father's coat. *Utah State Historical Society.*

Inside, the mine entrance and main tunnel caved in. Rail lines twisted. Roof supports snapped. Ventilation controls (concrete stoppings and overcasts) were destroyed, and the air and escape shafts filled with gas.

One hundred feet away in the company's office, the miners' metal identification checks were blown off the racks. A number of miners were working in the "first dip entries," others were a mile from the entryway and more were deep within the tunnels. All were entombed.

Dom Bertoglio. Mario Cappelleti. Mike Dacemos. Frank Fieldsted. Martin Kimball. Joseph Kirby Jr.

According to the U.S. Mine Rescue Association, the gas and coal dust explosions "started as a methane ignition" attributed to the inadequate watering down of the previous shift's stirred-up coal dust and the open flame "of a fireboss's cap lamp" that he used to relight a "key-locked flame safety lamp" that had gone out.

Rescue crews, composed of courageous volunteers from the mining district, came out in force. Mine rescue cars were sent from Dawson and Butte, Montana. Medical teams arrived from Salt Lake City. Government officials were called in. The Red Cross marshaled aid to the devastated families. While friends cooked and sewed mourning clothes, the Knights of Phythias hall was converted into a morgue.

Mrs. Henderson; Archie Jr., nine; and Myrtle, twelve, after they lost Archie Henderson, who was also killed in the mine explosion. *Utah State Historical Society.*

Tony Malax. William Morrison. Tony Spendall. Stylianos Spyridakis. Archie Henderson.

Raging fires, debris and poisonous gasses impeded rescue efforts. Several "helmetmen" nearly succumbed to the deadly gases. George Wilson, who led the rescue crew from Standardville, died from asphyxiation when his nosepiece separated from his helmet.

Temperatures dropped, but the heroic rescuers refused to stop until the last charred, dismembered or broken and nearly unrecognizable body was removed from the mine. It took nine days.

Orson Ungricht. Kanakis Virganelakis. S.C. Yum. Edwin Jones. George Kappas. John Slovenski. Mell Seely. Thomas Rees. Andrew Komfosh.

Grieving widows and children were suddenly faced not only with loss but also with economic uncertainty. Those from Greece, Italy, Wales and Japan struggled with the language and customs of their new homeland.

Governor Charles R. Mabey raised $132,445 to supplement their monthly compensation (some $64) received from the mine company. The state hired social worker Annie D. Palmer, who visited and helped assess ongoing needs.

It was a struggle, but the women survived. They made do, raised their kids, relocated, remarried, found employment and started businesses—but they never forgot.

James Preano. Alfred Rice Jr. Frank Piccolo. Joe Tellerico.

More names. All lost. One bitter March.

PART XI

Headstrong

Born in the Mountains of Italy, She Was Her Dad's Go-To Gal

In 1904, Mary (Maria) Lucia Nicolavo Juliano was born in San Giovanni in Fiore, the mountainous region of Calabria, Italy. She was raised, she said, in her grandmother's loving arms, while her father, Giovanni Nicola, journeyed to the United States in search of economic opportunity.

From the 1890s to the 1920s, numbers of Italian immigrants answered the call for unskilled labor in America's mining and railroad industries. They came west, historian Philip Notarianni notes, because they were "attracted to organized labor and saw it as a way to improve their lot."

During the 1903–04 Carbon County coal miners' strike, they were a major force in the labor conflict between the strikers and Utah Fuel Company.

Giovanni, known as John Nick, worked in eastern coal mines before heading to Carbon County. After five years, he saved enough money to send for Mary and his wife, Maria Teresa.

"We came by ship," his daughter said in 1987 interviews archived at the University of Utah's Marriott Library.[46] "I remember going on deck to the edge of the ship and watching the fish jump up and splash in my face. We went straight to Price and then Mohrland where my sister was born."

The family grew to fourteen, "although Mama lost two," Mary said. Leaving her grandmother behind was heartbreaking. "She was the love of my life. And I never got to see her again."

Mary's father worked the Mohrland, Spring Glen and Hiawatha mines. He worked the coke ovens of Sunnyside. "When a fine young man got killed

Mr. and Mrs. Bertolina making a life in Helper, Utah, circa 1914. *Utah State Historical Society.*

in Mohrland, Papa almost went crazy because he had to wrap him up and bring him out dead," Mary said.

John Nick walked out of that mine but worked in others to support his family. He also took up farming. He bought a house near Wellington. "It was too small," said Mary, "so the three of us built another."

Eleven years old at the time, Mary nailed narrow laths, chiseled doorjambs for locks and hung doors with her father while keeping up with her chores. After school, she'd often beat the bus home and be working in the fields as it rumbled by.

John Nick was strict and, shotgun in hand, didn't take kindly to boys calling.

"I think he was afraid I would leave him," Mary said. "Then who would he have to rely on?"

The family grew vegetables and fields of corn and wheat. They cured meats and made tasty cheeses. In summers, they'd load their wagon—later, their Dodge truck—with produce to sell in Standard, Rains, Castle Gate, Carbonville and Kenilworth.

"People would know who was passing," Mary explained. "If they needed something, they'd stand by the road and wait for us."

A Carbon High School student, Mary rose early to milk the cow and get her brothers and sisters ready for school. She would sew their shirts, cobble their shoes, cut their hair and their dad's, take care of the gardening and handle the household accounts.

"If something had to be bought or needed doing, Papa would come to me," she said. "Don't get me wrong. Mama wanted it that way. She was smart but couldn't speak English well."

Mary wanted to be a linguist. She wanted to travel. Besotted with suitors—"Tony had a beautiful accordion"—she definitely didn't want to marry.

However, the moment she saw coal miner and emergency rescue worker John Juliano walking toward her "with such pride on his face," she wanted to know "what made him tick."

Fifty-seven years, five babies—four born at home—and several mining towns later, she figured she knew.

John Juliano died in 1984.

"A good husband, strong in body and strong in mind, he wasn't afraid of anything. Try as I can, I can't forget that special man," she said.

Mary died in 1993 and was buried in Price City cemetery, not far from home.

Chapter 42

Hisaye Tsutsui Among the Last of the "Picture Brides"

When Hisaye (Suzuki) Tsutsui arrived in San Francisco en route to Utah on March 18, 1920, she believed she was "amongst the last of the picture brides, on the last [such] ship" permitted to enter America.

She may well have been. Earlier that month, the Japanese government stopped issuing passports to picture brides so as to reinforce amiable relations with a United States embroiled in anti-Japanese sentiment.

Hisaye was born in 1898 in a small village in the Kochi prefecture, a mountainous region on the south coast of Shikoku that was terraced for wheat, corn and barley cultivation. Her family raised "rice in the wet, marshy land and used fertilizer made from cut mountain grass and cow dung," she said in interviews archived at the University of Utah's Marriott Library.[47]

They wove rice stalks into *waraji* (straw sandals), grew sweet potatoes, raised silkworms and turned *yanagi* and *hajikusa* (willow plants) into paper. "We used some of the paper and sold the rest. That was our method of living."

The family's *mura* (village) was small and the walk to school long. The only hospital was ten miles away. The rare doctor who made house calls often traveled by horse and was always busy. When her fifty-three-year-old father died of kidney failure, they struggled to run the farm on their own. America looked promising.

Hisaye was four years old when her future husband, Mojiro, and one of her brothers left Japan for Hawaii. "I don't remember the details but I do remember being carried on the back of my mother as we went to see them off."

Between 1885 and 1924, nearly 200,000 young Japanese men equipped with eight years of compulsory education traveled to Hawaii to work as laborers on sugar and pineapple plantations. Half returned home penniless, while some 180,000 others sailed into the city ports of Seattle and San Francisco, seeking employment there and in neighboring states.

Hisaye's brother relocated to Salt Lake City, married and worked in a downtown *udon* (noodle) shop. Mojiro worked the railways in Montana, on Utah farmlands and in the mines.

"I can't say I knew him, because I was so young when he left," she said. "I didn't know about his business, what kind of person he was, or about his feelings. I don't [even] know whether his parents asked him if he wanted to get married or not. All I had was a vague picture of him. Don't you think it was that way for most picture brides?"

When they married, Mojiro was a thirty-five-year-old working in Payson. Hisaye was twenty and in Japan. Wearing traditional wedding attire, she married by proxy and left for America carrying one blanket and a small woven basket of clothes. Saying only that the ship's quarters were cramped with tight, narrow bunk beds, Hisaye wasn't seasick, frightened or lonely.

Arriving at San Francisco's immigration office, she held out her photo of Mojiro, who had arrived early carrying presents.

"I must have looked amusing to others wearing my Japanese kimono, *haori* [jacket] and *obi* [sash] with a western hat and boots," she said.

Their Payson home was "plain and built of wood." A separate structure housed a square wooden tub and a fire pit underneath. Alongside her "gentle" husband, Hisaye tended sugar beets selling at twelve dollars a ton. She craved *satoimo* (taro) during pregnancy, bore five children and "learned how to cook rice in an American home."

In 1930, the Tsutsuis moved to Salt Lake City and specialized in growing green celery. "At the time, we had no tractor. We'd put a harness on the horse and strap the plow-cultivator around its body. It was hard work. The constant use made our arms so stiff, I often wondered how we ever did it."

But they did.

In 1952, Mrs. Tsutsui became an American citizen. She died in 2000, weeks shy of turning 102.

Chapter 43

Determined Women Homesteaded Utah, Too

When the Homestead Act of 1862 offered undeveloped federal land west of the Mississippi River to private citizens, who knew the proverbial expression "Go West, young man" would embody a growing populace of self-reliant, single women?

From the get-go, droves of single and married men raced westward to stake their claims. Yet, by the early twentieth century, historians estimate 12 percent of western homesteaders were single women, mothers, divorcées and widows.[48]

In Utah, the promise of free land tempted Kate L. Heizer, an Iowa native who in the early 1900s staked her claim on former Indian land in the Uintah Basin in northeast Utah. It also prompted Russian immigrant Cecilia Weiss to take up dry farming near southwest Beryl. It wasn't easy.

The U.S. Congress passed the original Homestead Act during the American Civil War (1861–65) as a means to eradicate the practice of slavery deeply ingrained in the South, promote western settlement and help shape the American West into an agrarian economy.

The act, revised in 1909 and 1912, allowed any adult citizen over the age of twenty-one—who had "not borne arms against the U.S. Government"—opportunity to claim 160-plus acres of public land for settlement and cultivation.

The only requirements were to "prove up" (improve) their site by building a dwelling, working the land and maintaining at least seven months of annual residency. Within six months, a homesteader could purchase the

property from the government for $1.25/acre. If she proved up three to five consecutive years and paid a minimal registration fee, she would hold title to the property free and clear.

In the 1913 heydays, the Homestead National Monument of America reported more than eleven million acres were claimed—some acreage better than others.

"Luck was on my side," Kate wrote in *Sunset Magazine* of March 1921. "To get a piece of land having good soil and which water could be secured was a concern of first importance."

Emotional endurance, individualism and physical stamina were requisites for a remote lifestyle that built character, political equity and a chance for prosperity.

Money was also crucial. Homestead filing, surveying and notary fees exceeded $150. Water rights were dear. There were travel costs and food provisions to consider. Farming and building supplies, equipment, irrigation systems and livestock had to be purchased. For most urban women, hired help was a necessity.

Kate had her log cabin built from trees that grew on her property. Consulting others, she learned homesteading techniques. But she had to live and work elsewhere to earn enough money to pay expenses and prove up her land.

She taught school in the Ioka area of Duchesne County and spent holidays, long weekends and summer breaks at her homestead. She'd journey by stagecoach to the nearest station—fourteen miles short of home—and pay a driver to take her the rest of the way, often arriving at dusk.

"The stillness was intense," she wrote. "But the quiet was soon broken by the near and ferocious howling of coyotes."

In Escalante country, Cecelia Weiss filed on land where "not a tree was in sight clear to the horizon," she told *Sunset Magazine* in June 1916. "The gray-green sagebrush covered the flat valley like a shimmering Persian rug."

Cecelia walked three-quarters of a mile for a bucket of water, dug six hundred postholes for fences and learned to harness a horse. She paid a neighbor $3.50 per day for plowing and $50.00 to build her home. Dubbed "the piano box," the eight- by ten-foot wooden structure housed a single bed, table and chair, bench, bureau, clock, chintz fabric, cook stove and looking glass.

The homesteader spent $1,000 to prove up her land. She also had to prove citizenship as her name was accidentally dropped from the family's naturalization papers.

Undaunted—the *Salt Lake Telegram* (1916) called her "a plucky girl farmer"—Cecelia went to court, proved her citizenship and got title to her land.

Chapter 44

Tough Homesteader Wedded Five Men
But Was Happily Married to Life Itself

When thousands of potential homesteaders traveled great distances to stake a claim, "prove up" their property and begin new lives, one Utahn, whose life was as colorful as her name was long, didn't have to travel far to find her piece of heaven on earth.

In 1914, forty-year-old Josie Bassett McKnight Ranney Williams Wells Morris—four times divorced and once a widow—proved up land in the Blue Mountain Cub Creek region, ten miles east of Jensen in Uintah County.[49]

The oldest of five, Josie was born in Arkansas but raised in Brown's Hole, a remote valley tucked away in northeastern Utah bordering south-central Wyoming and northwestern Colorado (the same remote area that called out to John Jarvie).

Josie's father, Herb Bassett, was a gentle, educated man drawn west by his brother, Sam, who extolled the area's unparalleled beauty.

A former 49er, Sam believed the clean mountain air would cure his long-suffering brother's asthma. Josie's mother, Elizabeth, was a southern belle and feminist who rode sidesaddle. She was a go-getter who could, and apparently did when need be, "rustle" for their livelihood.

"My mother took the lead in our family and was handy with a shotgun," Josie said in Everett L. Cooley's 1959 interview, archived at the University of Utah's Marriott Library.

When the post office was built in Brown's Hole, Mrs. Bassett declared "Brown's Park" a more suitable name. It stuck.

The Bassett home, outfitted with a private library, stringed instruments and a portable organ, welcomed all visitors, from businessmen to outlaws, with no questions asked.

Josie was educated at St. Mary's of the Wasatch in Salt Lake City but thrived in the wilderness. An excellent marksman, she was independent, outspoken and feminine—a cause célèbre for controversy, myths and legends.

Josie was a teenager when she met Butch (Robert) Cassidy, who worked or hid out at the Bassett ranch. Some folks thought they were lovers.

"My father thought he was nice to talk to," Josie said.

In 1892, Elizabeth died from a burst appendix, and Josie married rancher Jim McKnight. They had two fine sons before she drove him out of the house at gunpoint.

"He wasn't bad, but I'd rather live with the coyotes than a drunken man," she said.

One write-up intimated she killed him. "He needed something," she acknowledged, adding mental cruelty to her divorce papers.

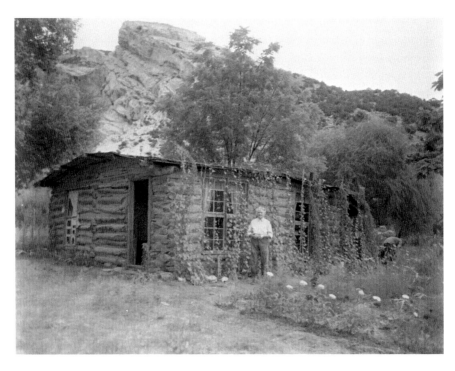

Josie Bassett McKnight Ranney Williams Wells Morris at her Cub Creek homestead on the west end of the Blue Mountain. *Uintah County Regional History Center.*

Her fourth husband, "a good farmer and a good man as ever lived," departed in a drunken stupor. Strychnine residue found in the bottom of a coffee mug sparked an inquiry. The grieving widow went to court and was acquitted.

When another husband mistreated her horse, she gave him fifteen minutes to leave. He took five.

Settling in at Cub Creek, the now single homesteader cleared brush, camped out, chopped wood, built her cabin, tended to her animals and gardens and collected mail in neighboring Jensen by horseback.

In 1924, she rebuilt her home and cut her hair short. Saving long skirts for weddings and funerals, she took to wearing bib overalls or trousers.

During the Depression, Josie hosted a homeless family and spent the winter in a dugout. When Prohibition struck, she operated a still and bootlegged whiskey.

Taken to court for "cattle rustling," she dressed up and survived, thanks to a hung jury. Eight years later, the seventy-year-old grandmother took third place in a horserace.

"I've never been thrown off once," she said.

Josie lived on her homestead for nearly fifty years, beloved and aggrieved by neighbors. The progressive woman never had electricity, never wanted it, rarely aged, encouraged physical activity and was steady on her feet.

In December 1963, she tripped, broke a hip and dragged herself indoors. The stalwart nonagenarian held on till May.

Chapter 45

Psychic Widow Founded
Spiritualist Utopia

Near to God and far from man, Marie Ogden founded a religious community in the wilderness of Dry Valley, fourteen miles north of Monticello in San Juan Country, in 1933. She called it the Home of Truth.

Ogden, a widow from Newark, New Jersey, was an educated woman and talented amateur pianist. Married to a successful insurance executive, she raised two daughters and was active in community affairs and welfare reform. After her husband, Harry, died from cancer in 1929, the grieving wife turned to metaphysics and spiritualism to communicate between this world and the next.[50]

She was encouraged by spiritualist William Dudley Pelley's tales of otherworldly encounters and briefly supported his mission. An American extremist claiming the ability to levitate, Pelley's politics may have caused a rift in their relationship. In 1933, Pelley organized the anti-Semitic Silver Legion in honor of Adolf Hitler.

Parting ways, Ogden wove astrological elements, numerology and the principles of pyramidism into her metaphysical study and touted this esoteric philosophy across state lines.

She lectured on the occult, natural disasters, preordained catastrophes, final judgment, reincarnation, resurrection and redemption. She believed herself "divinely-informed." She communicated with God through a typewriter.

One revelation delivered through its keys led the psychic to Utah's high desert to purchase one thousand acres of land. Another "automatic writing" prophesied a cataclysmic meltdown of the world, a transformation in

southeastern Utah from arid desert to tropical paradise and the "rebirth of society" from within the commune's faithful.

True believers from New York to Boise descended on the new utopia.

The Home of Truth comprised three physical groupings, constructed several miles apart, called "portals." In the outer portal, colonists built a communal home, a single men's dormitory, a woodshop and guest quarters. The middle portal contained residential homes, multiuse buildings, a commissary, a chapel and an unfinished cobblestone church.

The inner portal, according to Ogden, was sited on the "exact center of the Earth's axis," guaranteeing everyone's survival. This complex included cabins for single women, Ogden's domicile and, later, her grand piano.

At its height, one hundred colonists relinquished their personal possessions and financial assets, which, collected by Ogden, went toward the betterment of the community. They cleared ground and built a windmill-powered water pump, concrete cistern, homes and furniture. They gave up tobacco and alcohol and wrestled with celibacy.

Some unsuccessfully prospected for gold in the Blue Mountains. Others, unable to farm the hardscrabble land, leased garden plots near Monticello or worked for hire. A few raised chickens and purchased local beef and mutton. After another revelation, there were those who ceased eating meat.

In 1934, Ogden bought the *San Juan Record* and, as publisher/editor, added a column on metaphysics. She received ongoing communication from God. Convinced she could raise the dead, she offered promises of an afterlife.

Cancer-riddled Edith Peshak, of Boise, Idaho, took stock in the seer's self-promoted restorative powers. She and her husband, Elmer, were colony members and contributed generously, hoping for a spiritual cure.

In 1935, Peshak died. News of her death was kept quiet because the poor woman was "between worlds." To "stimulate" Peshak's pledged revival, Ogden applied resuscitation therapy—ritualistic washings, forced feedings and the laying of hands—three times daily for four months.

By the time the county sheriff got wind of the corpse, he determined that Peshak's mummified body posed no health risk because the climate was so dry.

Two years later, Ogden publicized her intent to again revive Peshak. The State of Utah and the Peshaks' son requested a death certificate. No body was found.

Ogden insisted neither death nor suggested cremation had occurred, and members fled.

Largely abandoned, Ogden lived in the colony for nearly forty years. She wrote metaphysical papers, taught piano to Monticello children and used her typewriter to converse with God—and Mrs. Peshak.

At ninety-one, Marie Ogden died in a nursing home in Blanding with no resuscitation requested.

PART XII

Hard Times

Chapter 46

Depression Brought a Prosperous Utah to Its Knees

Once I built a railroad, I made it run, made it race against time. Once I built a railroad; now it's done. Brother, can you spare a dime.
—*"Brother, Can You Spare a Dime"*

In 1929, a crowd gathered downtown on Main Street and watched haplessly as the ticker tape on the *Salt Lake Tribune* building tumbled. After a record high of national prosperity, the stock market collapsed and the country spiraled into one of the worst economic downspins in American history.

During the Great Depression of the 1930s, banks and businesses failed, factories and stores closed, farm prices dropped, benefits dried up and unemployment soared. Twelve million citizens were suddenly jobless and without savings. Thousands lost their homes. For nearly a decade, the popular song "Brother, Can You Spare a Dime" wailed the nation's despair.[51]

"I don't think there's one person out of a thousand now that would believe what we went through," Theodore "Pete" Houston told me during a visit at his home in Sandy. Pete had worked in steel mills, logging camps and stone quarries before the Depression cut him to the core.

In 1933, Utah's unemployment rate was the fourth highest in the nation. One of three Utahns was out of work. Those employed suffered dwindling hours and severe pay cuts. Others peddled wares, went door-to-door seeking labor in exchange for food or became shoeshine "boys." Families moved in together. Teenagers took to the road—a few less mouths to feed. And passing transients clambering to work in the cities were run out of town.

Bread lines, soup kitchens and "city-operated shelters" opened along the Wastach Front. They were branded "Hoover cafés" by a populace increasingly frustrated with President Hoover's inability to stop the Depression.

"We were lucky to find jobs raking leaves, digging ditches or cleaning streets," Pete said. "Many people couldn't find work and went hungry for days. It was hardest on the kids. Imagine, children living on a crust of bread."

Hoover endorsed state and local relief rather than federal intervention. Responding with lists of demands, Pete and one hundred others rallied at the State Capitol and downtown's City-County Building.

"We fought to establish work in the place of unemployment. We fought to get food to the people who had nothing to eat. We fought for a place to live," he recollected.

"Sometimes, we were met by thugs hired to fight us off. Then our protests would turn into real bloody battles. But we had to keep putting pressure on our local government to get things going," he said. "We were desperate."

In the 1930s, Utah marriages and births went into a slump. Divorce rates rose. With scarce jobs, married men were first to be hired; unmarried men feared dismissal because they were single and working single women, most of them teachers, were forced to resign if they married.

As the Depression deepened with no respite in sight, some lost faith in the American system, their future and themselves.

In 1929, Salt Lake resident Jack Findling had a charitable bent and was a leader in his community. He owned a woman's apparel shop, the Boston Store, on Main Street and dabbled in stocks and bonds. His home on upper Wolcott Avenue maintained a ballroom in the basement, frescoes on the walls, a rosewood bar, walk-in refrigerator and a kitchen daily steeped in the aroma of homemade pastries, sweet noodles and coffee cakes.

Then the bottom fell out.

"My grandfather lost a lot of money and found no way whatsoever to recoup his losses," said Joanne McGillis, who was a toddler when he died. "He had always helped others. Now he felt like an albatross around his family's neck. He ended up committing suicide."

Bereft of assets, broke and broken-hearted, Findling's wife, Esther, sold their home, furnishings and possessions. She struggled to keep open the store.

"They were devoted to each other," McGillis told me. "Nana was devastated. She worked hard. She never remarried."

Lamb's Grill Has Been a Gathering Point for Nearly a Century

In 1925, ten-year-old Theodore John Speropoulos, aka Ted Speros, washed windows, cleared debris and burned tumbleweed at his godfather Tom Praggastis's grocery store in Bingham Canyon. He tended the soda fountain at the Greek-owned Royal Candy Company, where chocolates were made by hand and ice cream cones cost five cents. After turning eighteen, he learned the culinary trade at Latches Coffee Shop in downtown Salt Lake City.

In short order, Speros worked his way from busboy, waiter, cashier, maitre d' and occasional cook to become a restaurateur of landmark repute. His Lamb's Grill Café in the Herald Building at 169 South Main Street remains today one of Utah's oldest, continuously working eateries.

Yet, in early 1933, Speros's boss, Mr. Latches, wanted to branch out and open a second restaurant, the Golden Lion Café, in the same location. He signed a lease with building owner James L. White, had Speros purchase used equipment from a shuttered restaurant in the Tribune Building and sought more funding.

These were Depression days. Money was scarce. It didn't help that Latches was a gambler.

"Trying to fund his venture by betting on horses, he lost everything but his original café," Speros told me long after he retired.

Latches couldn't pay his debts, so the Golden Lion lay sleeping, its contents held by White in lieu of payment until 1939.

Then, just before World War II, bankers Marion Eccles and Fritz Champ encouraged Logan businessman George Lamb to relocate to Salt Lake

and lease the vacant space where the bankrupt Golden Lion had been. Lamb bought the furnishings, including a long, sleek black marble counter. He renamed the café and, on a handshake, initiated a thirty-three-year partnership with Speros.

"Lamb was ill and asked for a week's help," he said.

The war years "changed the face of downtown Salt Lake City and our lives," Speros recollected. Weekends in the city bustled with U.S. servicemen arriving from Hill Air Force Base, Kearns, Camp William and Dugway Proving Ground.

"As many as 700 soldiers came through Lamb's. We were all so busy, Main Street restaurants allocated certain days off to give our employees a break."

Deferred from active duty and assigned to operate a crusher at Magna Mill's flotation plant, Speros worked at Lamb's between graveyard and afternoon shifts, managing wartime food rations.

"Most of our dairy, red meat and scarcity items were obtained with coupons called red points," he said. Chicken, fish, tenderloin and club steaks were served along with Greek stews, moussaka and corned beef and cabbage. Soups were made from scratch. The buffet tables strained under vibrant mounds of seasonal melons and fruit.

In 1942, Lamb's employed twenty-seven people. Waitresses made $1.20 an hour; the chef, $1.34. While food was their specialty and white linen their signature, Lamb's clientele satisfied the palate with a "roomful of stories." And the café became a gathering place.

Tribune reporters sat at their own press table, a big wooden booth maintained for them. Passover seders for Rabbi Strom were held "Greek-style" in the large dining room. The Masons met in the backroom. While Republicans convened in one dining room and Democrats in another, a loosely organized "industrial relations council" settled issues at their table for sixteen.

Attorneys were plentiful. One, in fact, frequented Lamb's so often that when he died, his chair was removed and a photograph, flowers and lit candle were placed at his table until the funeral service had ended. A tradition was born.

Theodore John Speropolous, best remembered for offering free meals to the less fortunate and slipping someone on the street a five-dollar bill, died at home in 2006. *Zoé sé sás* (Life to you).

On a recent day at Lamb's, owned by Ted's son John, an eclectic group tagged the Murphers met at their regular table. Having done so for thirty-five years, rest assured, the place setting is theirs for years to come.[52]

Chapter 48

KSL's Radio Mimic Had FDR's Voice, Then Adopted His Efforts

G ood morning, everybody. This is Wally Sandack with your breakfast news bulletins from here, there, and everywhere."[53]

It was the mid-1930s, and speaking from KSL radio studios, young Sandack was grateful to have a say—and a job.

These were the days of the Great Depression, when banks and businesses failed, factories closed, one-quarter of America's workforce was unemployed, two million were homeless and, unless you held onto the farm, food was hard to come by.

A Chicago transplant, Sandack attended the University of Utah's law school and worked odd jobs to make ends meet. One was in the state fairground's Coliseum food concession, where his boss, *Tribune* street sales manager Charlie McGillis, promoted greyhound races.

Sandack netted twelve dollars a week to cover tuition, books and rent at Mrs. Cooke's boardinghouse on 322 University Street. He budgeted ninety cents for daily dining at the Coffee Cup, Ute Hamburger Stand, Joe Vincent's Famous Café and Scotties. He became a "purveyor of fine foods."

But it was the budding lawyer's penchant for mimicry that caught the ear of KSL's general manager Earl J. Glade. Hired to parody the *March of Time*, a traveling news format that dramatized documentary events, Sandack impersonated celebrity voices while anchoring the morning news. In between segments, he would pitch products from chewing gum laxative to pork sausage.

Celebrating the twenty-fifth anniversary of the Salt Lake Rotary Club in an address to the city, Sandack easily emulated the congratulatory voice of President Franklin Delano Roosevelt.

"Roosevelt was everybody's father—incredible and credible at the same time," Sandack later recalled in interviews archived at the University of Utah's Marriott Library. "He restored the faith we had lost in America through the last days of Hoover's administration. He wasn't afraid to make the government work for the people: to stop foreclosures on farmlands and homes; close and reopen banks with guarantees for deposit; commence the Social Security program; generate jobs for the unemployed; and put city kids into work camps to make *menshen* out of them."

In 1942, Sandack served in the navy and in 1946 retired from broadcasting to resume his legal work. Energized by Roosevelt's efforts toward the "relief, recovery, and reform" of this country, Sandack went into politics as a "liberal Democrat and political activist" who wanted to "do some good."

Over the years, he rose in rank. In 1952, Sandack was elected Salt Lake County chairman. By 1960, he was a delegate to the Democratic Convention in Los Angeles. His evenings were taken up with political meetings, strategizing and platform writing.

"If you make up your mind to get into politics, there's no way you can really lose," he said, "because organizational politics is hard work and most people shy away from it."

In 1967, Utah governor Calvin L. Rampton urged Sandack to run for the office of chairman of the State Democratic Committee. Acquiescing, the delegate found himself in another kind of coliseum in a different type of race.

After I'd been nominated, a man stood in front of an audience of three thousand people and charged that I should be disqualified," he said. A 1967 *Salt*

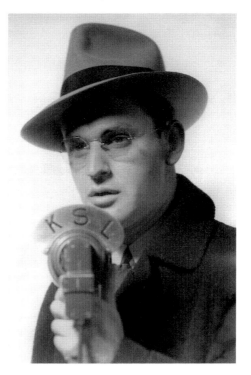

Wally Sandack reporting. *The Sandack family.*

Lake Tribune article reported the interloper requested "a recess for 20 minutes to consider that their nominee is a man who doesn't believe that Jesus is Christ."

"He didn't say I was Jewish," Sandack remarked, "and I wasn't frightened, but my head reeled."

Within moments, the article concluded, the offender "was hooted out of the coliseum and Sandack was elected by acclamation."

This grand gentleman, a champion of the underdog, suffered from dementia and died in 2011 at the age of ninety-seven. His wife, Helen, found his typewriter and, under the platen, yellowed paper and the beginning of a story—his—waiting to be finished.

PART XIII

In the Shadows,
Surviving the Holocaust

Chapter 49

Youth and Luck Were Key to Survival Under Nazi Rule

Part One: Her Broken Heart

In 1933, Adolf Hitler became chancellor and, in 1934, president of Germany. He overthrew the constitution, abolished human rights, blamed Jews for the country's failing economy and imposed the systematic murder of Jews, blacks, gypsies, homosexuals and political opponents of the Third Reich.

In 1937, Abe Katz was a husky fourteen-year-old living with his family in the city of Lodz in central Poland. His father peddled fruit from sacks strung over his shoulders. His mother went door-to-door doling out fresh milk from a cup. Abe liked girls and loved soccer but hated potatoes, so his mother always made him noodles from scratch.

"I was her only son and very close to her," Abe, eighty-six, recently confided from his Sugar House home.

When the Nazis occupied the city, Abe was pulled out of school, stigmatized with the Star of David identification badge and forced to work making horse saddles for the German army. One morning, he hugged his mother goodbye and started walking toward the factory. He never got there and never returned home.

"I know I broke her heart," he said. "The Gestapo picked me up right on the street. I never saw my parents since."[54]

Assigned to clean soldiers' billets, Abe slept in an empty warehouse until he was relocated to Auschwitz, stripped of his clothes, tattooed with the number B6282, handed prison garb and put to work.

"At first we dug ditches. Then we cut enough wood in the forest to make a big fire. That's when they brought in the gypsies and pushed them into the fire. We had to stay and watch. We were told we would be next."

At night, the prisoners slept on bare wood bunks, five people to a tier, pressed tightly against one another and facing the same direction. "Every hour or so, a whistle sounded, a light went on, and we turned over to the other side," Abe said. "Skin and bones, by morning, some people never got up anymore."

When Abe was shipped to the notoriously brutal Central Labor Camp Jaworzno, he worked in the coal mines and attributed his survival to youth and luck.

"For nearly two years, they fed us enough just to keep us working," he said. "Every day we walked four kilometers to the railroad car that took us closer to the mines. We worked with Polish civilians miners, hoping one would offer us food. Sometimes we would have to sit and watch them eat; other times, a good person would share a piece of bread or sausage. We tried to be assigned to them."

Abe's task was to build the narrow-gauged tracks used to transport the coal cars. "One day they drilled four holes and put in dynamite to blast the area. The foreman ordered another two holes. I was on my knees pounding the spikes when they started drilling again. All of a sudden, the movement set off the charges and the walls came down."

One post fell on Abe. It knocked him onto the rails and sliced his hand. Unable to flush it with water, Abe worked four more hours and marched back to camp for a weak bowl of soup. By nightfall, he had a temperature; his hand infected and swollen.

"I was always in a stage of unease," he said. "I mean, if somebody wanted to take you out, they could. But I never thought about dying. I never thought about women or life or school—only about surviving another day. This time was different, though. I didn't think I'd make it and I didn't even care."

Fortunately, his fellow prisoners did. Finding a piece of tin, they heated it over a little fire, held him down, cut sharply into his hand and drained the infection. "They saved my life."

As luck would have it, an older guard let him sleep. A week later, weighing eighty-four pounds, Abe returned to the filthy, unsafe, claustrophobic mine.

PART TWO: AN EMPTY CAN

"We were bone thin," Abe Katz said. "Every morning, we'd stand outdoors in a line and shed our pants. A doctor in uniform carrying a little stick would look at your body and point one way or the other. One direction, you knew you were finished. The other, you would survive to work another day."

"The Nazis wanted healthy men working in the coalmines," he said. "They fed you just enough to keep you going."

Working in the mines, Abe never thought about escaping. "Where could you go? There was only one tunnel in and one way out."

To do their work, the prisoners were rationed boots. Their prison shoes were inadequate. "They had thick wooden soles with a cloth cover nailed to the wood," Abe said. "Rather than walk, we slid. Marching in snow, rain, or mud, the material would get soaked through and fall apart. Again and again, we'd tear strips of material from whatever we had to tie around the entire wood—just to keep walking."

When the Nazi soldiers force-marched the Jewish prisoners from Jaworszno to an uncertain destination, Abe said those who couldn't walk were in peril.

"Young nineteen-year-old soldiers, punks, would come behind, yell, and poke you with their rifles. If you didn't move, you were done."

For weeks, the prisoners marched from one village to the next. Before they moved on, citizens were ordered to feed them, sparingly and often with potatoes.

At one point, Abe remembered a waterway and being herded into an open barge. "The breeze was cold, frigid, but it was better than walking." After a number of miles—"I don't remember how long we traveled"—they disembarked, marched through another villages, to a railway and into a cattle train headed for the town of Weimar.

A month later, Abe trod the last five miles, through the gate marked "Jedem das Seine" ("To Each His Own") and into the massive concentration camp called Buchenwald. Recollecting his inmate number as 126,000—the camp recorded over 238,000 prisoners—he was given an empty can.

"It was our lifeline," he said. "If you didn't have one, you couldn't get any food."

Punching two holes into the coffee-size tin, he threaded a piece of string through it and tied the can to his waist. "Wherever you went, you needed your can to stay alive."

Abe also blended into his surroundings. "I laid low, never volunteered, and pretended, I'm not here."

When news spread that the Allied forces were advancing, Nazi soldiers began evacuating the prisoners. "We heard the camp was mined. Prisoners were lined up daily. We didn't know where they'd be taken. Or if they'd be shot."

Abe disappeared into the sewer.

"There were four of us," he said. "At daybreak, a Jewish guard (*capo*) would open the sewer plate. We'd climb down the metal rungs and lie in the foul water. At night, the capo would open the plate and we'd sneak into the barracks."

Amid the bombings and fear of extermination, Abe remained hidden.

On April 11, 1945, General George S. Patton's U.S. Third Army, Sixth Armored Division, arrived to liberate Buchenwald. By then, the lid opened, and twenty-year-old Abe emerged emaciated, filthy, free.

Chapter 50

Nothing Above a Whisper

PART ONE: RUNNING FOR THEIR LIVES

In 1938 on the outskirts of the city of Kolomyja in what was then Poland, five-year-old Herman Spiegel fished for carp in well-stocked private lakes. He spent family vacations in the lush Carpathian Mountains and in winter chipped ice to draw water from a well. Herman had three siblings: Hilda, Jacob and Lunia.

Life was good.

Their parents, Moses and Sally, owned land they leased to Ukrainian farmers, a warehouse and two homes. In one, they rented out shop space and ran a general store and tavern. Business was thriving. Then not.

In 1939, the family weathered four years of Russian occupation and economic nationalization. They became farmers. When Nazi Germany seized the city in 1941, they tried to become invisible. Then they ran for their lives.[55]

"My father was hardworking, opinionated and gregarious," Herman told me during a visit in his Salt Lake City home. "He had friends—Polish, Ukrainian and German—spoke several languages and loved to debate. He didn't think Hitler would amount to anything more than a corporal and painter."

Under German occupation, Jewish property and assets were immediately confiscated. Intellectuals were arrested and tortured. The infirm and elderly were imprisoned and infants used for target practice.

In March 1942, the Kolomyja ghetto was assembled in three appalling sections, each surrounded by barbed wire and walled off from the rest of the now "Aryan" city. Streams of bewildered and frightened Jews were deported into the congested ghetto.

Some three thousand Jews were destined for extermination in the Belzec death camp operated by the German Schugtzstaffel (SS), while the nearby Szeparowce Forest seeped with blood graves, mass murders and "forest liquidations."

"We walked into the ghetto wearing everything we could and carrying everything we had," Spiegel said. "My father found a room with a [concealed] storage space in the bottom floor behind a small house."

Fortunately, one Ukrainian friend hid their possessions. A Polish woman offered loaves of bread. Johan Rippel, a German "but never a Nazi," gave Moses proper work papers so he could "exit the ghetto to collect feathers and down for the German army and hopefully smuggle back food."

Police *aktions* (raids) occurred often during Jewish holidays and in the dark. "On the first raid, we escaped by hiding in the small room," Herman said. "We had to be quiet and sit still for hours. Luckily the police didn't know we were there. But a thousand other Jews disappeared."

In a September *aktion*, 8,700 more were taken.

Herman and his father were outside the ghetto when a surprise raid took the life of his youngest sister.

"When we returned, I saw blood coming from Lunia's ear," he said. It happened so fast the slight, sleeping child who was deaf could not be saved. "My mother never stopped grieving."

Then everyone was given notice to register. "My father wouldn't," Herman said. "He knew what it meant." Instead, Moses scrambled to find one safe place after another.

"One time my mother saw a light glitter briefly in the dark and roused us to get to a safe place across the street." Herman said. "As we were running towards it, SD thugs—*Sonderiensts* under the SS—were jumping a fence a hundred yards away. We were lucky we made it."

When the SS burned one ghetto to the ground, they shot hundreds of Jews as they tried to escape. By October, 4,500 more were transported in cattle cars to Belzec. When they closed the second ghetto, people were crammed into the last remaining one.

It was during a raid that, hidden in an earthen basement with a group of others without food or light, Moses knew there was no other place to go but out.

"He tried to convince them to do the same, but they couldn't—didn't—move," Herman said. "You have to understand. Traditions were gone. Many had lost their families. They were starving and exhausted. They were being chased, and they didn't know where to go or who to trust. They couldn't think."

It was wintertime and bitter cold.

"It was midnight," Herman said. "We were wearing all our clothes when we walked in a line towards an open board in a wooden fence. I believe my father knew it was there. We followed him into the deep snow."

Part Two: In Hiding

Trudging through snowfields away from the ghetto, they headed toward a barn owned by the Ukrainian friend.

"He was surprised to see us," Herman said. "My father didn't like the look in his eyes. He thought he might betray us, so we disappeared that night without a word and hid in the fields. I don't remember eating anything that day or the next."

A Polish friend, Mr. Straszewsky, offered them short-lived relief.

"It wasn't safe. He was too close to the city," Herman explained. "He did know a Ukrainian farmer who would take us in for a price. And somehow my father had known to hide some gold coins before we went into the ghetto."

At night buried under burlap in Straszewsky's wagon, the family was taken to a gated farm with an unattached barn near the forest.

Told to hide and be quiet, Moses paid dearly.

"You had to be careful," his son said. "They could take your money and kill you."

Confinement in a loft behind bales of hay for eleven months took its toll. Lice bred in the seams of their woolen clothes. Hygiene was near impossible and medicine unavailable. Exhausted, Moses and Jacob risked discovery seeking food in nearby villages.

Moses continued paying the farmer, who "with a wife in rags, wore great pants and wonderful boots," Herman said. "Neighbors became suspicious of him. Sometimes, people would come to the barn to steal from the farmer. So you had to be very careful and very quiet."

During harvesting—and to dispel rumors he was harboring Jews—the farmer routinely opened his gates. The Spiegels fled to other barns, into the woods or onto open fields.

When the farmer suddenly evicted them, he was brutal. Their nerves were shattered, and the risks were high.

"That night, my father signaled Mr. Rippel," Herman said. "The man was hesitant. He represented the law. Nazis visited daily. He had children. What would happen to them if we were caught? But he said, 'If I send you away, I will never see you again.'

"For five months, we hid in his stable and never spoke above a whisper," Herman said.

Their liberation would come in 1944, courtesy of the Soviet Red Army, a year before the fall of the Third Reich.

Soldier Soon May Not Remember His Story, But We Will

Fleeing from the Gestapo, Ernst Gunter Beier, twenty-two, rode his motorcycle out of Germany toward France and, on September 1, 1938, boarded presumably the last ship sailing to America: the German liner *Columbus*.[56]

His mother had purchased the ticket. A family friend secured a bike, a BMW-750, for his escape. Midway at sea, the young man heard the ship's engines idle. The captain had received orders to return immediately to Germany. War was imminent. And the passengers, many of them Jewish, were terrified.

Instinctively, Beier reached for his childhood talisman, a copy of Goethe's *Faust*, a poetic adaptation interpreting man's wager with the devil and redemption. He read, *"Die Stunde kommt, sie wiederholt das Spiel"*—"the hour arrives and the game is replayed"—and awaited his fate.

As children, Ernst and his older brother Hans were raised in a traditional German home in Breslau. Beier attended school in the mountains, skied with peers and found youthful love, one who shared his interest in the "Faustian bargain."

But he witnessed the subtle cues of anti-Semitism escalating from childish taunts and skirmishes to public abuse of an even more terrorized Jewish society. And he tried to dissuade members of his Jewish scout group from printing and circulating BBC anti-Nazi material tucked inside matchboxes, saying the boys were "earnest but foolhardy."

When a scout's younger brother took an illegal flyer to school, both siblings were picked up by the Gestapo and severely beaten. The others had to get out of Germany fast.

Now in the ship's hold with his motorcycle—after all, it had saved his life—Beier knew he would never go back.

"It was absolutely frightening waiting to hear what the captain would do, or what we were going to do, or 'could' do," the former University of Utah professor and psychotherapist told me in his downtown Salt Lake City home.

Two days later, the captain ordered all on deck. After an excruciatingly long silence, he informed the passengers that he had neither enough culinary water nor fuel to return to Germany and instead would push on.

"But I know he didn't do it for that reason," Beier said.

Hans, who had immigrated earlier, greeted his brother in New York. They then worked feverishly to find safe passage for their mother. The Nazis had long seized her late husband's factory and confiscated their possessions.

When Japan bombed Pearl Harbor on December 7, 1941, Beier tried unsuccessfully to enlist in the U.S. Army. A second attempt landed him on Utah Beach in France on D-Day with the Twenty-eighth Infantry. Fighting in five major battles, he was captured in the Battle of the Bulge and sent to Germany's prison camp, Stalag 9B.

"It was very, very hard," he said. "We were all very hungry." Given watery soup and meager bread, within months, many lost a third of their weight. Raw recruits died because "they had no time to prepare in battle and mentally gave up on living."

One prisoner threatened to expose Beier as a Jew. Another protected him. But it was his knowledge of Faust and the instability of a madman that saved him from death.

A dreaded Gestapo officer, Dr. Schatten was known to interview and dismiss prisoners before shooting them in the back. He now wanted to interrogate Beier.

As fellow GIs signed well-wishes on a handkerchief, Faust's line, "to my heart reveal a deep and mysterious wonder," ran through Beier's mind. He asked they hold his piece of bread.

Inside a stifling room, Schatten, stroking his gun, alternated between niceties and menace as he grilled the exhausted soldier.

Suddenly inspired, Beier recited Faust's opening "Prelude in the Theatre" to an astonished Goethe lover. They parlayed into the terrifying night. When Schatten released him, his bread was waiting.

At home today, Dr. Beier navigates the stages of Alzheimer. We can be grateful his story is set on a course that will not let us forget.

PART XIV

World War II: Behind Barbed Wire, in Action and on the Homefront

Youngest Internees at Topaz
Proved Most Resilient

After Japan attacked Pearl Harbor on December 7, 1941, 1,500 Japanese Americans considered "enemy aliens" by the FBI were immediately picked up for questioning. Simultaneously, fearing espionage, the U.S. imposed restrictions on some 112,000 people of Japanese ancestry living in California, Oregon and Washington—coastal areas designated "war zones of the Pacific frontier."

By April 1942, these people were forced to surrender homes, possessions, civil liberties and rights to wartime hysteria, racial bias, evacuation and internment sanctioned by U.S. Executive Order 9066.

In *The Price of Prejudice*, historian Leonard J. Arrington writes the "uprooting of over a tenth of a million people was unbelievably restrained. [S]tunned and bewildered by the arbitrary action, the overwhelming majority followed the principle of *shikataganai*—'realistic resignation.'"[57]

Within weeks, forty thousand *Issei* (Japanese immigrants prohibited citizenship by the 1870 U.S. Naturalization Act), seventy thousand *Nisei* (American-born U.S. citizens) and numbers of third-generation Japanese American *Sansei* were sent to hastily constructed assembly centers before being transferred to one of ten remote internment camps.

Some eight thousand wound up in Topaz Internment Camp in Utah's Millard County. Many were children and teenagers; exemptions were granted for college-bound Nisei, if universities would have them, and U.S. servicemen.

In 1942, Ted Nagata was a seven-year-old Topaz internee. The Salt Lake City graphic designer told me it wasn't until college that "it all sunk in," but he remembers the confusion and tension families endured.[58]

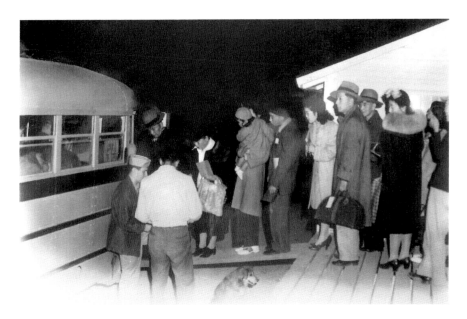

The evacuation of Japanese—young and old, American citizens or not—without due process of law. *Utah State Historical Society.*

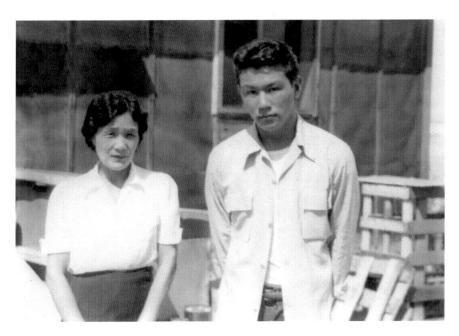

Kogiku and her teenage son George Murakami in Topaz. *Special Collections, Marriott Library, University of Utah.*

"Because we look like the enemy, we must be connected to the enemy," he said. "There were no trials, no hearings. I don't recall anyone sending a letter telling us what was going to happen. Just posters on telephone poles ordering us to get rid of what we could and report for deportation within seven days."

Taking only what they could carry—losing everything else—the Nagatas moved into a rancid horse stall in California's Tanforan Racetrack and then into a barrack for multiple families.

"We strung sheets to make walls providing the only privacy between us," he said. "We stuffed straw to make mattresses." Devastated by such events, many, including his mother, withdrew into silence.

After six months, they were sent to Topaz.

Reined in by tall, barbed-wire fences, sentry booths and armed guards, Topaz existed on twenty thousand acres of barren, dusty, mosquito-ridden land with temperatures soaring above 105 degrees in the summer and plunging well below zero in winter.

The site included forty-two blocks each with twelve single-storied barracks of one-inch pine frame-and-tarpaper construction, electric lights, few fixtures, a pot-bellied stove and no insulation or running water.

Privacy was near impossible. Communal, crowded and noisy, for some *Issei*, gardens miraculously grown in "arid alkali soil" may have provided respite in otherwise surreal surroundings.

And the *Nisei*? No doubt, youth attributes the spirit of survival.

"We were young," Nagata said. "It was an adventure. We took field trips past the barbed-wire fences, and went on hikes. We had more freedom in Topaz. But we didn't have freedom in America. We were still prisoners."

Retired produce buyer George Murakami, seventy-nine, whose father sold his dry goods store for pennies on the dollar, told me that internment was "hard on my folks. It was bad, but I was sort of young and had different things on my mind."[59]

Fifteen years old, Murakami stored his prized comic book collection, which he never recovered; packed four pairs of Levis, jackets and a bugle; boarded an "old train with armed guards and covered windows"; transferred to an army truck; and stepped off "into the endless dust of Topaz" and teenage whirl of school, sports, bugle corps, friends, dances and competitions.

"Guards would shout, 'Japs are Japs,'" Murakami said. "You couldn't say anything. They could put you in another camp. But we were busy all the time. We even played football in Delta. We're small. The [Delta] girls laughed, never thought we'd win. But we did."

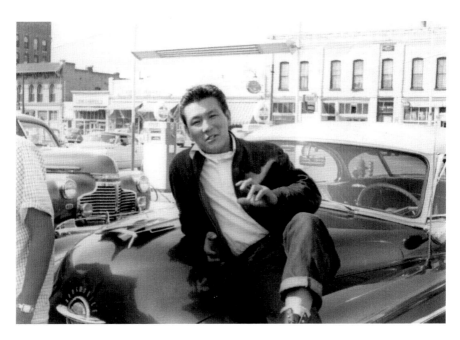

George Murakami, finally free, having done nothing wrong but be Japanese at a time of wartime hysteria. *Special Collections, Marriott Library, University of Utah.*

Innocent of any charge of espionage against the United States, on October 31, 1945, the internees were released and Topaz liquidated.

Murakami's family could not return home. There was nothing left. Relocating to Salt Lake City's Japantown, a small neighborhood on 100 South Street between 200 West and 300 West Streets, they lived in the Imperial Hotel until they got their bearings.

Chapter 53

When Rifles Were Pointed In, Not Out

On December 7, 1941, sixteen-year-old Grace Fumiko Fujimoto Oshita was attending Buddhist services in San Francisco when she was urgently called home. Japan had just bombed Pearl Harbor, and America declared war.

"Edward Kanta Fujimoto, my father, had no idea what was going on," Oshita, eighty-one, said in her Salt Lake home surrounded by paper cranes, family portraits and artifacts of wartime internment.[60]

"He'd been trout fishing with friends at the foot of the Sierra Nevada and on the way back was surprised to be stopped by armed soldiers at the [San Francisco-Oakland] Bay Bridge."

Edward was a student in Japan when his parents, Genpei and Tsuya Fujimoto, left for San Francisco in 1910 and established the Fujimoto Miso Company. Registered in California's Soyfoods Center as "the earliest known miso plant" in the United States, it produced fermented soybean paste for restaurants, grocers and mail order.

Seven years later, Edward followed his parents and eventually took over the company after his father's death. Although prohibited citizenship by the anti-Asian 1870 Naturalization Act and restricted from owning property by the 1913 Alien Land Law, he built a successful business.

"My father was a likable person who got along with everybody," Oshita said. "He was also an expert classical shakuhachi [bamboo flute] player and accompanied musicians during koto [thirteen-string zither] recitals."

Yet, on February 22, 1942, Edward was considered a risk and taken to an Immigration and Naturalization Service facility for evacuation.

"As soon as we heard, we raced over, but he was gone," Oshita said. "I never got to say goodbye."

In one censored letter sent from North Dakota, Edward wrote he heard Grace calling out his name. In another, he told his second wife, American-born Shizue Nakamoto (Grace's mother had died), to close the factory.

"She worked feverishly emptying the building, hiring thirteen truckloads to throw away [perishables] and moving equipment into storage," Oshita said.

Allowed only what they could carry, personal possessions were lost, stolen or sold for pennies on the dollar. In May 1942, strong-willed Shizue sold their car within minutes before leaving with her family for San Bruno's Tanforan racetrack. At the temporary internment center, they were assigned to Building 18, Apartment #6.

"A horse stall is what it was," Oshita said, "with nothing in it but army cots. All along the way, you could hear people crying. Exhausted, we did the same."

In September 1942, they were relocated to Utah. Walking into Topaz internment camp, Grace became a number: resident 533 of family number 14701.

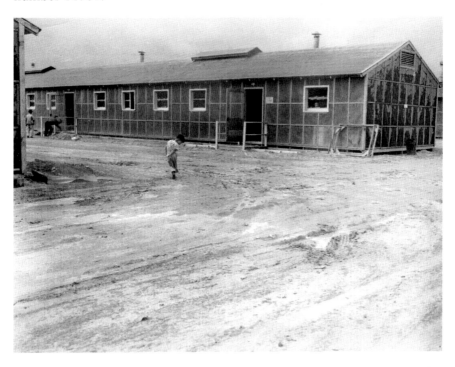

A desolate scene on one of young Marc Goto's first days in Topaz. *Special Collections, Marriott Library, University of Utah.*

"Inside the compound, a bugle corps played, an over-sized banner greeted us with 'Welcome to Topaz: Jewel of the Desert,' but rifles were pointed at us, not outward, and we knew it was no use to question why this was happening."

The family immediately answered "yes" on a loyalty questionnaire and heeded Edward's many letters to "show kindness for everybody."

Shizue interpreted instructions and messages for non-English-speaking women. Her brother installed privacy partitions in otherwise open barracks. He built furniture from scrap lumber. Tsuya carried coal-filled buckets and tended the pot-bellied stove. Grace graduated high school and worked at Topaz's elementary school, earning eight dollars a month.

"We were very busy trying to live as normal as possible," she said.

But their routine does not belie reality.

"From one day to the next, we didn't know what was going to happen," she said. "Psychologically, not being with my father and constantly worrying about him was traumatic. First and foremost, our resolve was, if he had to go to Japan, we would, too, for no other reason but to become a whole family again."

Nearing war's end, Edward was returned to Grace.

Chapter 54

Japanese Americans Served with Valor in World War II Combat

When the Japanese attacked Pearl Harbor, American-born Nelson Akagi was a nineteen-year-old freshman attending California Polytechnic College. In April, he was "a pretty scared kid," the Utah resident said in unpublished papers archived at the University of Utah Marriot Library.

Told to return home, he worried about unintentionally breaking curfew and travel restrictions imposed on Japanese Americans. By May, his rights were taken away. He was classified as an alien enemy and unable to register for the draft.

Within weeks, the Akagi clan lost their homes, orange groves, olive business and farm acreage. Paid for in full, everything was sold for ten cents on the dollar.

Avoiding relocation into one of the ten remote camps that interned 110,000 people of Japanese ancestry, the Akagis agreed to farm sugar beets for the Utah and Idaho Sugar Co. They were given eighteen hours to evacuate. Leaving behind tomatoes ready to harvest, they were herded onto a guard-posted, shade-drawn, run-down passenger train and taken to Parker, Idaho.

"The evacuation was done without due process of law," Nelson said. "But there was never a shadow of doubt about our loyalty."

On February 1, 1943, the U.S. government reversed its position on recruitment. Nelson swore allegiance in response to the War Department's loyalty questionnaire and joined the volunteer Japanese American 552nd Field Artillery Battalion of the 442nd ("Go for Broke") regimental combat unit.

Training as a machine gunner, Nelson numbered among fourteen thousand Nisei (second-generation Americans of Japanese ancestry) serving honorably in the U.S. military.

Also in service were 1,500 members of the original 298th and 299th Infantry Regiment of the Hawaii National Guard. Reclassified as the 100th Infantry Battalion (One-Puka-Puka), they were segregated and "unassigned to any other military organization."

On September 26, 1943, the 100th landed in a trouble zone in southern Italy. Steadily advancing fifteen miles a day, they captured a railroad station, took on "German machine gun fire and rocket launchers" and succeeded in pushing German troops farther north.

In January 1944, during the Battle of Monte Cassino, British and Allied forces launched an offensive to overtake the Gustav Line—the German army's 1,700-foot-high northernmost mountainous defense position—which was key to reaching Rome.

The 100th regiment fought over rugged mountains and across ravines sown with landmines, barbed wire and booby traps. After four battles and five months of fighting, Cassino was finally taken at great cost.

The Allies suffered more than fifty thousand casualties. Losing two-thirds of its soldiers, the sorely reduced 100th was designated the "Purple Heart Battalion."

In May 1944, Nelson crossed the Atlantic Ocean and headed toward combat. "Somewhere north of Rome, the 442nd caught up with the 100th Battalion and went into battle together," he said. By mid-October, they fought in the Vosges Mountains of eastern France.

"We fought in thick forests that were wet, cold and dense with fog," said Nelson. Maintaining silence and pushed beyond endurance, "we were

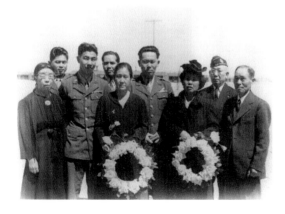

Gold Star mothers, having lost their American sons to war, still needed to stay within barbed wire. *Special Collections, Marriott Library University of Utah.*

committed to rescuing the trapped Battalion of the 141st Regiment, 36th Texas Division," Nelson said. "The Germans fought hard."

Hidden mines and trees rigged to explode beleaguered the men as they edged toward the frontline and the "Lost Battalion." Within five days, the 100th/442nd saved the 211 soldiers, incurring 800 casualties of their own.

Agaki, relieved of machine gun duty, was made into a scout and sent to the front line. The 100th/442nd continued fighting with valor, earning more honors than any other regiment of its size and term in service.

A lesser-known Nisei role involves five thousand Japanese interpreters of the U.S. Military Intelligence Service (MIS). Assigned to combat divisions throughout the Pacific, Burma, China, India and Europe, their contributions and sacrifices—including "cave flushers" meeting with enemy soldiers—helped lead the Allied forces to victory.

On November 2, 2011, Utah veterans Nelson Akagi, Nob Iwamoto, Masami Hayashi, Dr. Taira Fukushima and Casey Kunimura received Congressional Gold Medals in Washington, D.C. We are indebted.[61]

Bowing to Silence

Born in 1899, Chiyo Ongino Matsumiya only had to close her eyes to return to Fukui, Japan. There, she could see her family plant rice in long rows on terraced fields, hear her father beat drums during *Obon* festivals and watch him read and write letters for the illiterate.

With each memory, she'd say, "Things like that I can't forget."[62]

Between 1885 and 1924, 180,000 Japanese immigrants journeyed to America. At sixteen, Jinzaburo Matsumiya sought providence in this country's railroads and, by 1911, had risen to the rank of section foreman. Seven years later, he traveled to Fukui to claim his bride, Chiyo, in *omiai-kekkon*, an arranged marriage settled between families.

"In those days, you obeyed your parents," Chiyo explained in papers stored at the University of Utah's Marriott Library. "You had to say '*hai!*' [yes]."

She was eighteen and ready for Utah.

"My mother was an adventurer who easily replaced kimonos for western dress," her daughter Jeanne Konishi, eighty-four, told me during a visit in her home.

After two years spent farming, Matasumiya went back to work as section foreman in Tintic Junction. A remote crossroad between the mining towns of Silver City and Mammoth, it was also a way station for trains traveling between Los Angeles and Salt Lake.

Two freight cars placed parallel to each other, widened and roofed over became the Matsumiyas' new home. Commodities were brought in by train, water was stored in large tanks and bathing was limited to once a week.

Chiyo planted vegetable gardens. She raised chickens and pigs; stoked wood-fired stoves; washed clothes by hand; took in isolated, lonely Japanese workers during the Depression; and spanned culinary cultures with Japanese rice and headcheese. The children took the bus to school in Eureka. They had lessons in Japanese at home.

"My mother enjoyed Buddhist picnics in Salt Lake," said Jean. "And since we had a piano, she invited Mormon parishioners to hold their services in our living room."

On December 7, 1941, when Japan bombed Pearl Harbor and war was declared, police searched Japanese homes in Utah for short-wave radios, cameras and guns. "They opened drawers, cupboards, scattering everything to the floor," Jeanne said, "They took my father's shotguns, a .22 rifle. His Colt pistol was never returned."

In the dead of winter, warm wastewater was diverted onto cold railroad tracks in Garfield and suspicion fell to the Japanese. Jinzaburo was fired and ordered to leave "town" within three days. Accused with no recourse, the Matsumiyas, like so many of their countrymen, bowed to silence.

Relocating to Eureka so their children could finish the school term, they went next to Payson looking at places to rent. "Even a barn would do," Chiyo said, "but we were told it wasn't for rent to 'Japs.'"

They looked toward Salt Lake. "You couldn't buy a house east of Main Street, and it was difficult for Japanese to find work," Jean remembered.

After thirty years with America's railroad, her father became a dishwasher. Her mother, who was an expert seamstress, worked at a men's store. Their house, located near 2100 South and West Temple, soon was populated with family, friends, boarders and chickens. No one mentioned the war.

"No matter what we felt about the war, we didn't talk about it—not even with our kids," said Chiyo. "We had to live and eat as usual. We just kept our mouths shut."

In 1953, Chiyo became a U.S. citizen, living three-quarters of a century in Utah before dying at ninety-one. In Tintic Junction, a look back uncovers fragments of a *chawan* from which the family once ate hot rice.

Utah Rosies Took Over Labor Fronts, Bolstered Patriotism

Betty Evans can't remember where she last flung her hard hat or stowed her steel-toed shoes, but she'll never forget the summer of 1943 and the late afternoon shift at the Remington Small Arms Plant on Redwood Road.[63]

Joining the growing ranks of "Rosie the Riveter," depicted in Norman Rockwell's 1943 *Saturday Evening Post* cover of an American female defense worker, the blond, blue-eyed, University of Utah student helped the country's war effort by filling five-inch-long, fifty-caliber bullets with gunpowder.

"We put on work shoes so our feet wouldn't get caught in the machinery and asbestos work gloves to handle the bullets," Evans told me. "We took off loose jewelry, pulled our hair back under netting, and wore slacks—they were 'in' then—and sweaters because the warehouse was really cold. And noisy. We needed ear plugs because the machines and bullet cases clanged whenever we touched them."

During the Great Depression of the 1930s, Utah's unemployment rate hovered well above the national average; one in three citizens was out of work, and many relied on federal relief programs. Affirming the growing crisis in Europe, Utah governor Herbert B. Maw, congressional delegates and private business leaders looked at myriad ways to secure war contracts for the state.

When Pearl Harbor was bombed, America entered the war, and the nation rushed to strengthen its military defense.

Utah seemed ideal. Inland and protected by a mountain range, it had in place a transcontinental railroad, four national highways and a connecting

air travel system. It was central to the major coastal ports in Seattle, San Francisco and Los Angeles. Moreover, it had existing military installations, an eager labor pool and local industry support. Awarded fourteen military contracts, some forty thousand positions opened for immediate hiring.

But as Utah's men marched to war, the defense industry was besieged by severe labor shortages, so managers turned to women.

"We were all involved in the war," Betty said. "We had friends and family members that were fighting, wounded or killed. My brother was in the Pacific. My boyfriend was about to be drafted. We would have done anything to help."

Local Minute Women organizations, evoking the legendary Minutemen, went in search of women willing to work outside the home. Patriotic placards and banners were posted on poles and bulletin boards and ads placed in newspapers.

University students were tapped, and radio stations blared. Without skipping a beat, the call for female workers was answered. Thousands of women took over the work of men.

The *Salt Lake Tribune* reported in 1944, "Driven by the truly feminine urge to stand by their men, [women] are doing practically every job a man can do with the exception of heavy lifting, and as more men are called to the battlefronts, we are confident that their place will be taken by courageous, capable and patriotic women."

In 1940, females composed 17.6 percent of Utah's labor force. By 1944, the numbers doubled. Working at military installations and in private industry from Hill Field, Ogden Arsenal and the Tooele Ordnance Depot to Standard Parachute and Utah Copper, Utah Rosies readily took to the assembly lines. They drove tanks, cranes and forklifts; operated drills and blowtorches; shaped bullets; produced bombs; and painted roads. Although they earned sometimes as much as a dollar less than men, they broke labor traditions and democratized employment.

Earning sixty-nine cents an hour, Betty stood on a raised, railed platform sequestered between conveyor belts and noisy machines and sent empty bullet cases from one direction into another for filling. She said such labor reinforced patriotism and bolstered independence.

"I was responsible for my own being," she said. "Instead of asking my father for five dollars, I could not only earn money, but spend it the way I wanted."

By war's end, Betty had married her soldier and, like so many other Rosies, went home.

Chapter 57

A Thousand Female Pilots Take to the Skies

Within months after the Japanese attacked Pearl Harbor, the U.S. Army Air Force, faced with an acute shortage of male pilots, decided to use female pilots in domestic aviation to relieve their male counterparts for combat.

This was a first for the military. They knew little about women's adaptability, attitudes, strength or psychological bearings. So they turned to world-renowned pilot Jacqueline Cochran, who created in-country ferrying and training programs, including aerial navigation, target towing, assimilated bombing missions and conveyance.

Cochran had broken international speed and altitude records. President of the Ninety-Nines, an international organization of female pilots, she was a member of the Wings for Britain, delivered military aircraft from America to England and became the first woman to pilot a bomber across the North Atlantic.

Actively recruited, 25,000 young women stepped forward to volunteer, and about 1,800 were accepted into the program. Learning to fly "the Army way," 1,074 graduated into the Women Air Force Service Pilots, or WASPS. Nell Stevenson Bright, who trained at the Sweetwater, Texas military flight school, was one of them.[64]

"We grew up in West Texas during the Depression years and were taught to contribute," Bright, eighty-nine, told me from her Salt Lake City home. "We were also told we could do anything if we worked hard enough. And I'd always wanted to fly."

Bright had graduated from college at nineteen, composed newspaper ads in Amarillo and "bummed rides to the airport every morning to get flight training." When she received her pilot's license and built up her hours, Bright enlisted in the Army Air Force (AAF) as a civilian pilot and earned her wings.

"We were paid $250 a month, had to buy our own uniforms, and though we were under military orders and considered officers, technically we were civil service." Bright said. "If one of us died—and thirty-eight women pilots did—the government wouldn't compensate the families to send the body home."

Parents couldn't display in their windows the traditional gold star symbolizing the death of a child in the line of duty. Nor did female pilots receive veteran status.

At the time, though, most thought only about flying.

"It wasn't glamorous work," Bright said, "but getting off the ground and into the air was a wonderful feeling."

Bright received primary and advanced flight training "just like the men," and learned to fly B-25 twin-engine bombers, P-47 pursuit planes, a couple of navy bombers and fifteen other types of aircraft.

Those in the ferry command transported planes from manufacturer to base and one coast to the other, making deliveries as far away as Alaska, where Russian pilots would take them overseas.

At Biggs Field in Texas, Bright flew assimilated bombing, gas and strafe missions. She towed target sleeves behind the B-25 for anti-aircraft boys to shoot at before going overseas.

"It was dangerous," she explained. "They were shooting live bullets. Sometimes they'd miss the target and hit the plane."

While in transition school at Mather Field, California, Bright and twenty other female B-25 pilots faced inequity with the same aplomb with which they took to the air. "The commanding officer didn't particularly want us eating in the officers' mess, but we were officers, so we did."

This attitude held sway when twenty Tuskegee airmen—the first black flyers in the armed services—arrived on base and were racially segregated. "These trained pilots and officers of the U.S. Army Air Force could not eat with us in the officer's mess," said Bright. "We spoke up. When they were finally allowed in, they had to sit away from everyone else. That was pretty bad, so we joined them."

When Bright's older brother, a crew chief on a B-25 in North Africa, returned to the States for R&R, his sister—first pilot on a B-25—offered to fly him home.

"He couldn't imagine it and wanted to take a bus."

But he didn't dare.

PART XV

Remembering Old Salt Lake

Chapter 58

Why Would I Go?

At dusk, heading toward Salt Lake City's downtown urban center of bling, i.e., the Gateway retail district, reflective orange-and-white striped traffic bollards led me on a detour around the backside of silent buildings, over an abandoned railroad track and onto a short but well-worn road.

In the dimly lit area overlooked by twenty-first-century gentrification, I caught a glimpse of the old city, when downtown was several blocks east and a young Esther Klein, born in 1906, knew it like the back of her hand.

"I don't think [all] the streets were paved then," Esther said in a 1983 interview archived at University of Utah's Marriott Library.[65] "I can see the old trolley cars and an old-fashioned dry goods store on Main Street called Cohn Brothers."

Louis and Alexander Cohn, Jewish immigrants from Russian Poland, were early entrepreneurs in the West, along with freight-shippers like Ransahoff, the Walker brothers and the business-oriented Kahns and Auerbachs.

Active in pubic life, Louis Cohn was elected to city council in 1874 and again in 1888. Cohn Brothers' ready-to-wear clothes, advertised in January 1885's *Salt Lake Herald*, pitched colored velvets for two dollars; black velvets, less; "heavy cloakings, 50 cents on the dollar"; and "brocades and silks" below cost.

"They didn't have cash registers in every department," Esther remembered. A pneumatic tube system, installed in the balcony, was used to whisk cylindrical carriers to various departments. "A salesman would twist open a little container, put the sales slip and money in, and send it up the tube." If change were due, compressed air would send it back down.

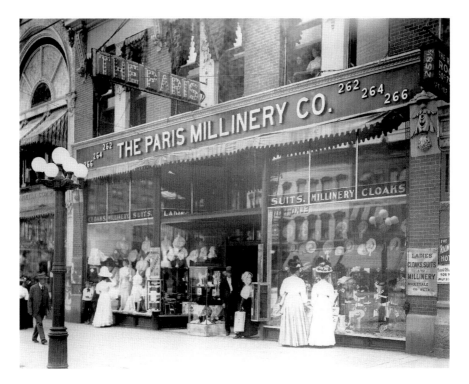

The elegant Paris Millinery Company, on 262–66 South Main Street, was owned by Jules Dreyfus and his father, 1908. *Utah State Historical Society.*

One day, after her sister Elizabeth fixed her hair in curls, they walked to the Walker Brothers building for a "tea" party. "It was some sort of sales gimmick," Esther said. "Little girls would get dressed up, bring their dolls, and have hot chocolate in the display window. We ended up with a little cup and saucer that I kept for years."

In the summer, the sisters bought sweets at Klein's Bazaar, window shopped at the Paris Millinery on Main Street and, for a family excursion, caught the train to Saltair, a resort on the shore of the Great Salt Lake, to "bathe in the deep waters on the south side of the railroad tracks."

Young Esther lived in an adobe house on 200 South and West Temple with a single globe light hanging in each of the two rooms and no indoor plumbing. Her father, Joseph, left Hungary as a teenager. In the 1890s, he picked fruit in Miami orchards and worked the railroad outside Yellowstone. Her mother, arriving at Ellis Island with little but a small trunk and bedding, immediately headed west. They met in Pueblo, Colorado, married and relocated to Utah.

"My father was tall, wiry, with thick strawberry-red hair, a mustache only he could trim, and really blue eyes," Esther said. "He was a laborer who did rough work at a smelter but never used rough language around us.

"He believed people should talk American when they were out in public," she said. "But at home, if they didn't want us to understand what they were saying, they spoke in Yiddish, German, Czechoslovakian or Hungarian."

On weekends, the Klein sisters and their older brother watched silent screen star Pearl White save herself in "The Perils of Pauline" series playing at the Mahesy Theatre above Broadway. They scanned Salt Lake newspapers and cut out free passes for vaudeville matinees at the old Pantages.

When they moved to 200 East and 600 South Streets, her father attended Congregation Shaarey Tzedek while the others went to Congregation Montefiore. During Yom Kippur, her mother always held the fast. Her father snuck out of services. They understood each other.

"She believed that was his pleasure," Esther said. He'd return "with a sack of grapes" to accompany her

When classmates told Esther she would have to live in Jerusalem because she was Jewish, she was stunned and said no. "I was born and raised here. Why would I go?"

It was her town.

Notes

Chapter 1

1. Eileen Hallet Stone, *A Homeland in the West: Utah Jews Remember* (Salt Lake City: University of Utah Press, 2001); Solomon Nunes Carvalho, *Incidents of Travel and Adventure in the Far West* (New York: Derby and Jackson, 1857).

Chapter 2

2. Church of Jesus Christ of Latter-day Saints members are referred to as LDS church members or Mormons. Born in 1801, Brigham Young led the LDS movement westward. He was president of the LDS Church from 1847 until 1877 and the first governor of the territory of Utah. Anyone who is not Mormon is considered to be a Gentile.

Chapter 3

3. See Brigham H. Madsen, *The Gentile Capital of Utah* (Salt Lake City: Utah Historical Society, 1980).
4. In 1862, Colonel Patrick E. Conner established Fort Douglas to protect the overland route from Indian attacks and prevent potential Mormon uprisings.

5. On the Auerbachs, see Judith Robinson, *Utah Pioneer Merchant: The Memoirs of Samuel H. Auerbach (1847–1920)* (Berkeley: University of California Press, 1998).

CHAPTER 4

6. See Michael S. Pemberton and Mary Ann Kirk, *Faces of Murray* (Murray City, UT: Printech, 2003).

CHAPTER 5

7. For more on the Greek community, see Helen Z. Papanikolas, ed., *The Peoples of Utah* (Salt Lake City: Utah State Historical Society, 1981); Leslie Kelen and Eileen Hallet Stone, *Missing Stories: An Oral History of Ethnic and Minority Groups in Utah* (Salt Lake City: University of Utah Press, 1996).

CHAPTER 6

8. Brian Shovers, "Walkerville: Butte's Sister Silver Town," 1986 papers at the Butte-Silver Bow Public Archive, Butte, Montana.

CHAPTER 7

9. Also see Hynda Rudd, "The Unsinkable Anna Rich Marks," in *Western Jewish Historical Quarterly* (n.d.). For more on the Tintic Mining District, see Philip F. Notarianni, *Faith Hope and Prosperity* (Eureka, UT: Tintic Historical Society, 1982).

CHAPTER 8

10. For more on Dr. Gleason, see Bill Sander, *The Gentiles: Their Life and Legacy* (Layton, UT: Kaysville/Layton Historical Society, 2004).

CHAPTER 9

11. Eleanor Swent and Joseph Rosenblatt, *EIMCO, Pioneer in Underground Mining Machinery and Process Equipment, 1926–1963* (Berkeley: University of California Press, 1992). See interviews and unpublished papers by Gregory T. Thompson and Allan D. Ainsworth, University of Utah Marriott Library.

CHAPTER 10

12. For more on Newhouse, see Hallet Stone, *Homeland in the West*, 101–5.

CHAPTER 11

13. For more on Cordova, see Kelen and Hallet Stone, *Missing Stories*, 498–504; Dahlia Cordova interview by author, May 2006.

CHAPTER 12

14. On Asian American experiences, see Ronald Takaki, *Strangers from a Different Shore* (New York: Penguin Books, 1990). Also see Kelen and Hallet Stone, *Missing Stories*, 196–246; William Louie and Bob Louie interviews with author, November 2007.

CHAPTER 13

15. McGhie Land Title Co., Abstract of Title, No. 45276; See Ronald G. Coleman, "Blacks in Utah History: An Unknown Legacy," in Papanikolas, *Peoples of Utah*; Doris Frye interview by Leslie Kelen, 1984, University of Utah Marriott Library, Special Collections; Kelen and Hallet Stone, *Missing Stories*, 71–73.

CHAPTER 14

16. For more on Kurumada, see Kelen and Hallet Stone, *Missing Stories*, 229–38.

CHAPTER 15

17. Sidney Matz interview with Leslie Kelen, 1985, Jewish Archives, University of Utah Marriott Library, Special Collections; Ruth Matz McCrimmon and Berenice Matz Engleberg interviews with author, 2000.

CHAPTER 16

18. Howard Brown interviews with Leslie Kelen, September 1983, African American archives, University of Utah Marriott Library, Special Collections.

CHAPTER 17

19. See online copy of BLM's "The Pony Express Stations of Utah in Historical Perspective" and Joseph J. DiCerto, *The Saga of the Pony Express* (Missoula, MT: Mountain Press Publishing Co., 2002).

CHAPTER 18

20. See online print of James Gamble's "Wiring a Continent" in the 1881 issue of *The Californians* and *The First Telegraph Line across the Continent*, published by Nebraska State Historical Society Books.

CHAPTER 19

21. See Kate Carter, *The Story of Telegraphy* (Salt Lake City: Daughters of Utah Pioneers, 1961); Utah History to Go, *Katherine Fenton Nutter: Utah's Cattle Queen*; online studies on western women telegraphers by Thomas C. Jepsen.

CHAPTER 20

22. Anna Belle Weakley Mattson interview with author, January 25, 2007.

CHAPTER 21

23. Ted Moore's "Fast Revolutions" in *Utah Historical Quarterly* (2011) studies the Wheelman and the Good Roads Movement. See online quote by Susan B. Anthony in "Wheels of Change: How Women Rode the Bicycle to Freedom."

CHAPTER 22

24. See Gregory M. Franzwa, *Alice's Drive: Republishing Veil, Duster and Tire Iron* (Madison, WI: Patrice Press, 2005).

CHAPTER 23

25. Jesse Petersen is also the author of *The Lincoln Highway in Utah*; Additional source, U.S. Dept. of Transportation's online article "The Lincoln Highway."

CHAPTER 24

26. William A. Douglass and Jon Bilbao, *Amerikanuak: Basques in the New World* (Reno: University of Nevada Press, 2005). Called "Home Comfort" in 1910, Sidney Steven Implement Co., Ogden, shipped its wagon in pieces for $550 to $650. In 1920, Ahlander Co., Provo, advertised sheepwagons built on a rubber-tire Model-T Ford frame.

CHAPTER 25

27. Jim Matsumori interview with Leslie Kelen, 1984, Japanese American archives, University of Utah Marriott Library, Special Collection; and with author, June 2005.

CHAPTER 26

28. See Clarion stories also in Hallet Stone, *Homeland in the West*, 189–212.

CHAPTER 27

29. See Kate B. Carter, *Fire Departments of Utah* (Salt Lake City: DUP, 1941).

CHAPTER 28

30. Also see Rochelle Kaplan, "The Spirited in the Land of Zion," in *Atsmi Uvsari* (Utah Jewish Genealogical Society, 2009); Hal Schindler, "Humorist Mined Mother Lode in Mormons and their Foibles," *Salt Lake Tribune*, 1995; Wesley P. Larsen, "Toquerville," in Kent Powell, ed., *Utah History Encyclopedia*, 1994.

CHAPTER 29

31. Dortha Davenport, *History of Junction and Its People* (self-published, 2005).

CHAPTER 30

32. Also see Harold Shindler's "The Oldest Profession's Sordid Past in Utah" in online version of the *Salt Lake Tribune. The Most of John Held Jr.* (Brattleboro, VT: Stephen Greene Press, 1972); Jeffrey Nichols, *Prostitution, Polygamy, and Power* (Chicago: University of Illinois Press, 2008).

CHAPTER 31

33. John Jarvie and Brown's Hole, http://www.nps.gov/history/history/online_books/blm/ut/7/chap3.htm BLM Cultural Resources Series (Utah: No. 7); John D. Barton, "Fort Davy Crockett," *Utah History Encyclopedia.*

CHAPTER 32

34. Richard McGillis interview with author, October 24, 2000; See Hallet Stone, *Homeland in the West*, 226–39.

CHAPTER 33

35. J.M. Cornwell, ed., *UPA: A Century Later* (Utah Press Association, 1996). Also see Sanders, "The Gentiles." Sanders interview with author, November 2012.

CHAPTER 34

36. Simon Bamberger's story was dictated to Leon Watters in 1924 on *Pioneer Jews of Utah* (New York: American Jewish Historical Society, 1952). A draft of the interview is in the Simon Bamberger Family Collection, MS 225, University of Utah Marriot Library, Special Collection. See Hallet Stone, *Homeland in the West*, 91–98.

CHAPTER 35

37. See Ronald W. Walker, *Wayward Saints*, University of Illinois Press, 1998, and "Godbeits" in Utah History Encyclopedia. Also, Beverly Beeton, "Women Suffrage in Territorial Utah," *Utah Historical Quarterly* 38 (1970).
38. The Lion House was the large residence built in 1856 by Brigham Young for his large family, including as many as twelve of the polygamist's wives and their children.

CHAPTER 36

39. Matthew J. Sander, "An Introduction to Phoebe Wilson Couzin," a final paper on women in the legal profession, 2000, including "A Speech by the Lady Bachelor at Law." Also see "Utah Women and the Right to Vote," online *Daily Herald*, September 28, 2003.

Chapter 37

40. See Beverly Beeton, "The Woman Suffrage Movement, 1869–1896," *Utah Historical Quarterly* 46 (1978); Deanne Glover, Kanab Museum curator, and Mount Carmel resident, Elaine Rogers, interviews with author, July 2008.

Chapter 38

41. See Elliott J. Gorn, *Mother Jones: The Most Dangerous Woman in America* (New York: Hill and Wang, 2001). Also Allan Kent Powell, "Labor at the Beginning of the 20th Century," University of Utah thesis, 1972, and Phillip Notarianni's 1972 interview with Dr. J.J. Dalpiaz, archived at the University of Utah Marriott Library Special Collections.

Chapter 39

42. Vito Bonacci interview with Leslie Kelen, 1987, archived at the University of Utah Marriott Library Special Collections.
43. See Phillip Notarianni, "Italianita in Utah," in Papanikolas, *Peoples of Utah.*
44. Filomena Fazzio Bonacci interview with Leslie Kelen, 1987, archived at the University of Utah, Marriott Library Special Collections. Also see Notarianni's "Italians in Utah," in *Utah History Encyclopedia.*

Chapter 40

45. See Stu Beitler's online copy, "The Castle Gate, UT Coal Mine Disaster, Mar 1924" for a complete list of names. Also see Marianne Fraser, "One Long Day That Went on Forever," *Utah Historical Quarterly* 48 (1980).

Chapter 41

46. For more on Juliano, see Kelen and Hallet Stone, *Missing Stories*, 262–68.

Chapter 42

47. Hisaye Tsutsui interview with Leslie Kelen, Japanese American archive, University of Utah Marriott Library Special Collections. For more on the Japanese community, see Papanikolas and Alice Kasai, "Japanese Life in Utah," in *Peoples of Utah*.

Chapter 43

48. Information on the 1862 Homestead Act may be found online in "Land Laws and Settlement," *Encyclopedia of the Great Plains*. Also see Marcia Meredith Hensley, *Staking Her Claim: Women Homesteading the West* (Glendo, WY: High Plains Press, 2008).

Chapter 44

49. See Josie Bassett Wells Morris, http://www.nps.gov/history/history/online_books/blm/ut/7/chap2.htm. Also Doris Karren Burton, *Dinosaurs and Moonshine* (Uintah County Western Heritage Museum, 1990).

Chapter 45

50. See Wallace Stegner, "Home of Truth" in *Mormon Country* (New York: Duell, Sloan & Pearce, 1942); *Salt Lake Tribune*, September 30, 1977; Bradley C. Whitsel, "Marie Ogden and the Home of Truth," *Communal Societies* 2 (2009).

Chapter 46

51. Author interviews with Pete Houston, 1991, and Joanne Spritzer McGillis, 2000. The popular Depression-era song "Brother, Can You Spare a Dime" was written by Yip Harburg in 1931, music by Jay Gorney.

CHAPTER 47

52. Lambs new owner, Francis Liong, from Los Angeles, is committed to fusing old traditions with new.

CHAPTER 48

53. Wally Sandack interview with Leslie Kelen, 1982, archived at the University of Utah Marriott Library Special Collections; and with author, 2000.

CHAPTER 49

54. Abe Katz interviews with author, May 2010.

CHAPTER 50

55. Herman Spiegel interviews with author, 2002 and 2010.

CHAPTER 51

56. Ernst Beier interview with author, September 1999.

CHAPTER 52

57. Leonard J. Arrington, *Price of Prejudice* (Logan: The Faculty Association, Utah State University, 1962).
58. Ted Nagata interview with author, August 2006.
59. George Murakami interview with author, September 2006.

CHAPTER 53

60. Grace Fumiko Oshita interviews with author, September 2006.

CHAPTER 54

61. Nelson Akagai's essay, "No More Perhaps," at the University of Utah Marriott Library Special Collection. Among other war material concerning the question of loyalty, online "The Lost Battalion," "Rescue in the Vosges Mountains by the 442d Regimental Combat Team," the "Congressional Gold Medal" and Julene Thompson, "Finally, Utahn Gets His Medal," *Deseret News*, January 6, 2003. Author interview with Judge Raymond Uno, November 2006, explained more on the internment camp experiences. "We were denied our constitutional rights, he said. "No due process. And especially the younger people now have become a lot more liberal, not agitators, but more vocal in the way they felt. I am really concerned that my children and grandchildren, everyone, that they get a fair shake."

CHAPTER 55

62. Chiyo Matsumiya interview by Bunny Matsumiya, March 1973; with Mitsugi Kasai and Kelen, March 1984, University of Utah Marriott Library Special Collections. Jeanne Konishi interview with author, 2005.

CHAPTER 56

63. Betty Evans interview with author, July 2007; Antonette Chamber, "Utah Rosies: Women in the Utah War Industries during World War II." University of Utah thesis, 1989.

CHAPTER 57

64. Nell Stevenson Bright interview with author, February 2011; Jean Hascall Cole, *Women Pilots of World War II* (Salt Lake City: University of Utah Press, March 1962). In 1977, the WASP received veterans' status; in 2009, they were awarded the Congressional Gold Medal by President Barack Obama.

CHAPTER 58

65. Esther Klein interview with Kelen, 1983. See Hallet Stone, *Homeland in the West*, 161–69.

About the Author

Transplanted from New England, Utah-based writer Eileen Hallet Stone's award-winning projects include nineteenth-century life, populations in crisis, community stories and ethnic histories. Her collected stories in *A Homeland in the West: Utah Jews Remember* were developed into a photo-documentary exhibit for the 2002 Winter Olympic Cultural Olympiad Arts Festival in Salt Lake City. Her earlier book, *Missing Stories: An Oral History of Ethnic and Minority Groups in Utah*, co-authored with Leslie Kelen, has added substantially to Utah's educational curriculum. She writes a "Living History" column for the *Salt Lake Tribune*; has one son, Daniel; and lives with her husband, Randy Silverman, in the eclectic Sugar House area of Salt Lake City.

George Janecek.

Visit us at
www.historypress.net
...
This title is also available as an e-book